Photos
for OS X and iOS

Take, edit, and share photos
in the Apple photography ecosystem

JEFF CARLSON

PEACHPIT PRESS

Photos for OS X and iOS
Take, edit, and share photos in the Apple photography ecosystem

Jeff Carlson

Peachpit Press
www.peachpit.com

To report errors, please send a note to errata@peachpit.com
Peachpit Press is a division of Pearson Education

Editors: Clifford Colby and Scout Festa
Production editor: David Van Ness
Copyeditor: Scout Festa
Compositors: Jeff Carlson
Indexer: Valerie Haynes Perry
Cover Design: Aren Straiger
Interior Design: Mimi Heft

ISBN 13: 978-0-13-417195-1
ISBN 10: 0-13-417195-0

9 8 7 6 5 4 3 2 1
Printed and bound in the United States of America

For Cliff, who has shepherded more of my words into print than perhaps anyone

Acknowledgments

My sincere thanks go out to the following people, who made it possible for this book to exist:

Cliff Colby for patience and enduring rambling phone calls and did I mention patience?

Scout Festa for her keen copyediting and proofing skills

Valerie Haynes Perry for writing the index (an underappreciated art)

David Van Ness for coordinating the book's production

Mimi Heft for designing an excellent book and template design

Everyone involved in printing, binding, and shipping the print book around the world

And for Kimberly and Ellie, supporting me every day in large and small ways

Contents

Introduction

The iPhone is the most popular camera in the world. Not the most popular mobile phone, but the most popular *camera*. It's taken the place of many point-and-shoot cameras for one reason: you can't argue with convenience. It's easy to capture a spontaneous moment using the camera phone in your pocket. Even when I'm out shooting with other cameras, I also snap photos using my iPhone.

But what happens then? Images can't stay on the iPhone forever. The answer is the twin anchors of Apple's photography ecosystem, Photos for OS X and Photos for iOS, tied together with iCloud Photo Library. Images captured on an iPhone, iPad, or iPod touch automatically sync to iCloud and are copied to all your devices. That also means you have access to your entire photo library wherever you are.

The Photos application isn't solely focused on mobile photography, mind you. Photos for OS X replaces Apple's earlier photo applications, iPhoto and Aperture, where you probably have years of images from several types of digital cameras stored.

This book takes you through the entire workflow of working with photographs on the Mac, from snapping and editing photos on iOS devices to managing them on other devices and the Mac. Use iCloud Photo Library to access all your photos no matter where you are, and iCloud Photo Stream to share photos with others instantly. Then take the photos further by making prints and cards, creating photo books and calendars, and building slideshows. I also walk you through the steps (and around potential pitfalls) of converting existing iPhoto and Aperture libraries to work with Photos for OS X.

Notes About This Book

I'm making a few assumptions about you, dear reader, to make sure we're both on the same page:

- You own a Mac, an iOS device, or both, which can run the included Photos apps. That means you're running a Mac with OS X Yosemite (version 10.10.3) or later, and iOS 8 on any iPhone, iPad, or iPod touch device.

- You know the basics of using Apple's products. I don't expect you to be an expert, but as long as you can get around easily, you're good.

- You own a camera (which may be your iPhone) and have photos you can work with. I don't provide sample files to download, but that's okay—I'd rather you invest your precious time on your own photos.

As you read, you'll run into examples where I've adopted general terms or phrases to avoid getting distracted by details. For example, I may refer to the "computer" or the "desktop" as shorthand for any traditional computer that isn't an iPad or iPhone.

The same general rule applies to iPad and iPhone models. For example, the iPad mini, despite its size, is still a fully functional iPad, so when I refer to "iPad" in general it applies to the iPad mini as well as to the larger, flagship model. Similarly, I don't always refer to specific models.

I also frequently refer to just the iPhone even though the information applies equally well to the iPod touch. I'm not being lazy, for two reasons: If I had to always type "iPhone, iPad, and iPod touch," I'd go quickly insane. Also, as I write this, the latest iPod touch Apple sells is the fifth-generation model, which was originally released in 2012. I suspect that unless Apple has something up its sleeve, the iPod touch as we know it will soon disappear.

When directing you to specific areas within iOS and OS X, I use a shorthand for locating them. For example, to access the preferences for the Camera app, I'll point you to **Settings > Photos & Camera**. That translates to "open the Settings app and tap the Photos & Camera button" (1).

On the Mac, settings are called *preference panes* and are found in System Preferences. So when I ask you to open the iCloud preference pane, it means "open System Preferences and click the iCloud icon" (2).

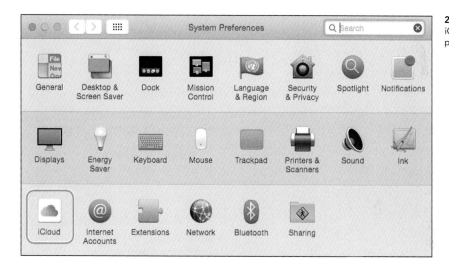

1 Photos & Camera settings on the iPad

2 Accessing the iCloud preference pane on OS X

CHAPTER 1

Capture Photos

We can't start a book about photography without capturing some photos, right? Lucky for us, it turns out that Apple currently offers some of the best cameras on the market.

Not long ago that would have been a controversial statement. Apple doesn't make any "cameras"—at least, not in the traditional sense. But I'm guessing you probably own an iPhone (or iPad or iPod touch), which might capture more photos than an old point-and-shoot or DSLR in your closet somewhere. I shoot with a variety of cameras, including DSLR and mirrorless models, but the convenience of snapping photos with my iPhone is unbeatable.

And it's not as if shooting with an iPhone means you're giving up a lot of image quality. Sure, it's limited in some ways compared to a DSLR—no optical zoom or interchangeable lenses, for example—but the results can be stunning. Apple dedicated an entire "Shot on iPhone 6" marketing campaign to prove it (www.apple.com/iphone/world-gallery/).

In this chapter, I cover how to make photos and videos using the cameras in the iPhone, iPad, and iPod touch. Later on, I'll go into detail about what happens to them further along in Apple's photo ecosystem.

Capture Photos Using the Camera App

It's time for me to make a confession: Even though dozens of photography apps exist, and even though I'm a photographer who regularly shoots in manual mode on my DSLR, I almost always use the built-in Camera app when I take photos using my iPhone. Here's why:

1. On your iPhone or iPad, press the Sleep/Wake button or the Home button to activate the lock screen.

2. See that little camera icon in the lower-right corner? It's a shortcut. Drag it up to open the Camera app directly (1.1).

When I see a photo opportunity and I have just my iPhone, it's usually something spontaneous. Being able to launch the Camera app and snap a photo within seconds makes all the difference.

Of course, you can also open the Camera app the traditional way, by tapping its icon on the Home screen.

1.1 Drag to open the Camera app from the lock screen.

Take a photo

The Camera app embodies the phrase "point and shoot." Position your subject on the screen and do the following:

1. Make sure the mode is set to Photo (which is the default) (1.2).

2. Tap the white shutter button to take a photo.

 Or,

 Press a volume button (either one) on the iPhone or iPad's case to trigger the shutter. This option is often easier than trying to "stab" the shutter button on the screen (1.3).

A thumbnail of the image you shot appears near the button. The photo is stored in your Camera Roll, a special album in the Photos app.

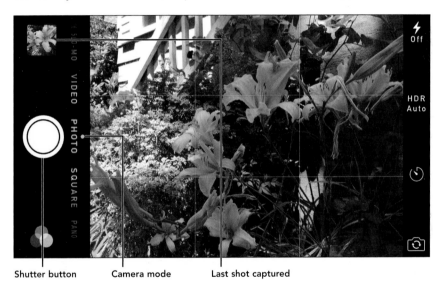

1.2 The Camera app interface

Shutter button Camera mode Last shot captured

1.3 Use the volume buttons to take a picture.

Adjust focus and exposure

The camera does a pretty good job choosing which items should be in focus and how bright or dark the scene should be. If people's faces are in view, the app will highlight those and focus on them. Sometimes, though, the app needs a little nudge:

- To choose a focus point, tap once on that spot on the screen. The app also uses that point as the basis for calculating exposure.

- To lock exposure and focus so they don't change even if you move the device, touch and hold until you see AE/AF LOCK appear at the top of the screen. It will remain locked until you take a photo or tap elsewhere on the screen.

- To adjust the exposure of the scene manually, touch to set a focus point and then drag the Exposure slider that appears to the right of the focus reticle up or down (1.4).

1.4 Adjust the exposure manually.

Exposure slider

Switch cameras

Remember during the dark ages, when we had to turn the camera around to take a selfie, not knowing if we'd actually framed ourselves in the image until after the shot? The front-facing camera on the iPhone and iPad saves us from that nightmare (even if the image quality isn't as good as the

back-facing camera; it's designed primarily for participating in FaceTime video calls). Tap the Switch Camera button to alternate between the two cameras (1.5).

1.5 Switch Camera button

Switch Camera button

▶ **TIP** When you orient the iPhone or iPad to take either a portrait (tall) or landscape (wide) photo, make sure the app is also oriented properly. Sometimes if I'm holding the device at an odd angle, or shooting top-down, the device doesn't click into the correct orientation, leading to photos that need to be rotated in the Photos app (which is easy, but an additional step). The entire interface doesn't shift when you turn the device, but some of the icons do. Look at the Switch Camera button to see how it's oriented, and turn the device to change it if needed (1.6).

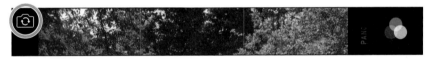

1.6 The Switch Camera button is a quick way to verify orientation.

Landscape orientation

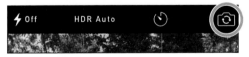

Portrait orientation

Capture photos in Square mode

The Camera app's shooting modes, such as Photo and Video, all capture different types of images—except the Square mode. Square is just like Photo, but it automatically records in a square aspect ratio. Swipe the mode names or tap one to jump to it.

Capture photos using the Apple Watch

If you own an Apple Watch, you can use it as a remote trigger to capture photos on the iPhone. It's great for snapping photos of yourself or a group when you're in the picture. Stabilize the iPhone on a tripod or some other method of keeping it steady, and then do the following:

1. On the Apple Watch, open the Remote Camera app. If the Camera app on the iPhone isn't already open, it automatically launches. You'll see a preview on the watch of what the iPhone's camera sees.

2. Tap an area of the image to set focus and exposure (1.7).

3. Tap the white shutter button to snap a photo. Or, tap the Timer button to start a 3-second countdown before the shot (and to prevent seeing your arm raised in every shot of yourself). (See "Timer mode," later in this chapter, for more information.)

4. Tap the Review button to see the photos on the watch.

Images you capture on the watch are automatically saved to the Photos app on the iPhone.

1.7 Capturing and reviewing photos on the Apple Watch

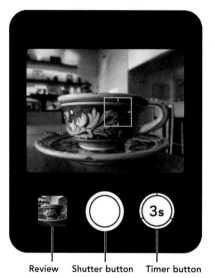

Review Shutter button Timer button

Photography Fundamentals: Composition

As you're lining up a shot, consider its *composition*—the way objects are arranged in a scene to help direct the viewer's eyes. There are plenty of "rules" for composition, and just as much reason to ignore that advice and frame a photo in a way that pleases you. I tend to fall in the middle; I do tend to set up my shots using some traditional composition guidelines, but sometimes an image works best when it's breaking those rules. Here are a few guidelines to keep in mind:

- **The Rule of Thirds:** Split the frame into thirds both vertically and horizontally, and align prominent objects along those thirds. For example, instead of putting a person directly in the middle of the shot, position them one-third the distance from either edge. The Camera app makes this easier by overlaying a grid on the screen; go to Settings > Photos & Camera > Grid to enable or disable it.

- **Leading lines:** Take advantage of lines or items in the scene that direct the viewer's eyes to the main subject **(1.8)**.

- **Framing:** Look for natural or manmade objects that frame the scene—tree branches that bend over a path, a barn window that looks out over farmland.

- **Background items:** Be conscious not only of your subject, but also of what's going on elsewhere in the frame. A famous example is taking a photo of someone in front of trees such that it looks like a branch is growing out of her head.

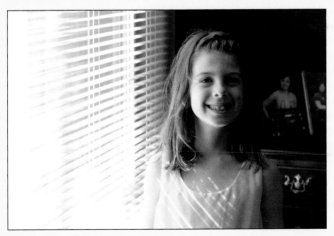

1.8 This photo demonstrates the rule of thirds (the girl aligned where a right-third line would be) as well as using leading lines (the blinds) to direct the viewer's attention.

The iPhone's flash

When you're shooting in dark or challenging lighting conditions, the camera needs more light to avoid overly dark photos. One method is to add new light using the LED flash on the back of the iPhone. The iPhone 5s and later incorporate a novel dual-LED flash: one warm, one cool. After the camera evaluates the scene, it fires the two LEDs in combinations that balance the color and do a much better job than earlier single-LED flashes of not blowing out the image with too much light.

To activate the flash in the Camera app, tap the Flash button to choose Auto (the camera decides), On (it fires every shot), or Off (no flash fires, even in dark situations) (1.9).

▶ **TIP** The flash can also be used as a flashlight. Swipe up in any app (even the lock screen) to reveal Control Center, and tap the Flashlight button (far left) to turn it on or off.

1.9 Flash control

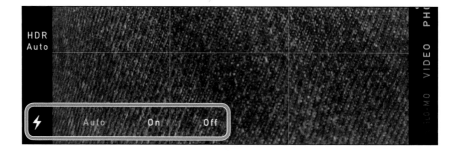

HDR

Another method the iPhone can use to add light to a scene is HDR (high dynamic range). In HDR mode, the Camera app captures multiple photos at different exposures—from very light to very dark—and combines them into one image that balances them. HDR is great for scenes where the subject is in shadow in the foreground and the background is bright (1.10), or when the overall lighting is dark.

To enable HDR, tap the HDR button and choose Auto, On, or Off.

1.10 The HDR version greatly improves the sky in this example, while still keeping detail in the shadowed foreground.

HDR

Original

In Auto mode, the Camera app displays a yellow HDR badge at the bottom of the screen when it detects that HDR will work better than a normal exposure.

▶ **TIP** When the Camera app captures an HDR image, it also records a regular version and saves that to the Camera Roll. If you prefer to keep only the HDR, go to Settings > Photos & Camera and turn off Keep Normal Photo under the HDR (High Dynamic Range) section.

Burst mode

Ever try to take a picture of a moving toddler? How many of those turned into artful blurs? The burst shooting mode on the iPhone 5s and later (and the iPad Air 2) captures up to 10 images per second. All you need to do is hold the shutter button—a running total of shots recorded appears near the shutter button (1.11).

1.11 Fill the iPhone's storage in record time with burst mode.

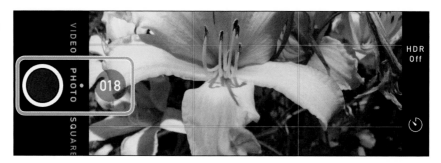

To avoid overwhelming you with potentially dozens of pictures, the Photos app picks what it thinks is the best one and presents that as the shot you see. You can also pick out other stills by doing the following:

1. In the Photos app, tap the burst you shot to view it.

2. Tap the Select button.

3. Scroll through the images and tap the ones you want to keep (1.12).

4. Tap Done.

5. In the dialog that appears, choose Keep Everything to continue to store the full burst, or choose Keep Only Favorites to save the ones you marked and delete the rest.

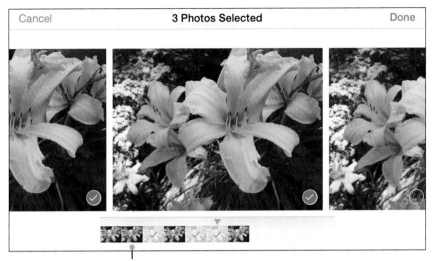

Circle indicates the image chosen by the Photos app.

Timer mode

Tap the Timer button to choose a 3-second or 1-second delay before the shutter fires. In the Camera app, the timer has a bonus feature: it captures a burst of 10 photos when the time is up, which helps avoid the inevitable shot where someone in the picture has their eyes closed.

▶ **NOTE** When the front-facing camera is being used, the timer is still available, but HDR and the flash are not options.

Zoom

Pinch outward with two fingers to zoom in, but keep this in mind: the camera lens doesn't actually zoom, so what you're doing is enlarging pixels in software. The result will be images that are softer than you may like.

Shoot using a filter

The Photos app, as you'll see in the upcoming chapters, includes preset filters that apply stylized looks to your photos, such as black and white or

a simulated instant-film appearance. You can also shoot photos with a filter active, allowing you to see just how that look will apply to the scene in front of you.

What I like about the filters is that they aren't permanently applied to the image you capture. The Camera app saves the original pixels that were recorded, so later you can change the filter or remove it entirely.

To shoot with a filter, tap the Filters button and choose one of the filters (1.13). The Filters button then appears in color to remind you that a filter is active.

► **TIP** When you shoot with filters, they remain "sticky" to the shooting mode you're in. For example, if you switch to Square mode and choose the Chrome filter, every shot you take in that mode will be made with Chrome. If you switch to another mode, the next time you return to Square mode the Chrome filter will be applied until you change it.

To remove a filter, tap the Filters button and choose the None option in the center of the screen.

1.13 Filters let you preview and record photos in that look.

Filter is applied.

Photography Fundamentals: Color Temperature

The term *color temperature*, sometimes referred to as *white balance*, describes how warm or cool a scene is. Most cameras include a white balance control that includes presets for shooting conditions such as Cloudy (which warms the scene) or Fluorescent, which accounts for the color casts given off fluorescent bulbs.

The Camera app does not include a way to adjust color temperature other than by specifying a focus and exposure point—the camera does its best to adapt to the scene. If you want manual control over the temperature as you shoot, look to a third-party app that offers more control (most of them do). You can also adjust color temperature later in Photos for OS X and most other image editors.

Shoot a Panorama

Traditionally, the way to make a panorama—an extra-wide photo of a scene—was to take a bunch of pictures side by side, and then use external software to stitch them together into one image. Apple's approach is different, and much easier to accomplish.

1. In the Camera app, switch to the Pano mode.

2. Hold the iPhone or iPad in its vertical orientation and tap the shutter button once.

3. Move the device in the direction indicated by the arrow, keeping the arrow's tip on the yellow line (1.14). The app will remind you if you move too far off the line or if you need to speed up or slow down.

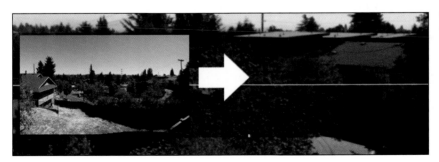

1.14 Capturing a panorama

4. When you want to end the panorama, tap the shutter button again to stop. Or, the capture ends when you reach the other side of the screen.

The Camera app records your action and stitches together the panorama as you shoot it, making tonal adjustments during the capture to avoid any jagged divisions.

▶ **TIP** You can shoot a vertical panorama, too. Start low with the device in landscape orientation and pan up.

▶ **TIP** Have you heard of the "panoselfie?" I thought it sounded like a joke, too, but it's actually pretty cool. Instead of turning your body around to take a panorama, stay in one position and turn the iPhone 360-degrees in your hands to get a panorama where you're in the shot (1.15).

1.15 The victims of a panoselfie.

Shoot a Video

I've written extensively about iMovie over the years, and let me tell you, the video-recording capabilities of the iPhone still make me shake my head in wonder. High-definition video in my pocket? From a device that also happens to be a small supercomputer and communicator? Amazing. Here's how to capture some of that amazement yourself:

1. In the Camera app, switch to the Video mode.

2. As with photos, tap to set a focus and exposure point, adjusting exposure by dragging up or down if needed. To lock focus and exposure, touch and hold a spot until you see AE/AF LOCK appear.

3. If you're shooting in a dark environment, tap the Flash button to turn the flash on (or set it to Auto and let the camera decide).

4. Tap the red Record button (formerly the white shutter button) to begin recording. The counter at the top of the screen indicates elapsed time.

 While you're recording, you can tap elsewhere on the screen to change the focus and exposure.

5. Tap the button again to stop recording.

You can also snag snapshots as you record by tapping the smaller shutter button that appears. Be forewarned that they're less than normal photo resolution (2720 by 1532 pixels on the iPhone 6) and at the 16:9 video aspect ratio, but that's better than trying to pull out a frame of video later.

▶ **TIP** By default, the Camera app records at 30 frames per second (30 fps), which is standard for video playback (movies you watch in the theater are recorded at 24 fps). The iPhone 6 and later can also record at 60 fps, which allows for smoother video—but also an increase in the storage required to save the movie. Go to Settings > Photos & Camera, and under Camera, enabled the Record Video at 60 FPS option.

▶ **TIP** Shooting and editing video is a much deeper topic than I need to go into here—in fact, I wrote an entire book about it! Learn all about video on iOS devices in *iPad and iPhone Video: Film, Edit, and Share the Apple Way*.

▶ **NOTE** Allow me to make a personal appeal? When shooting video, try to remember to hold the iPhone or iPad in its horizontal orientation. Video and film are horizontal, and even though you *can* record video vertically, it makes things difficult if you want to share or edit it later on—in most cases, you'll need to crop the image, potentially cutting out the very thing you were focused on.

Shoot a Slo-Mo Video

HD video on a phone is quite the achievement, but the iPhone 5s and later can do one better: slow-motion HD video. The iPhone 6 and iPhone 6 Plus in Slo-Mo mode shoot 240 fps, slowing the action to 12.5 percent of normal speed (the iPhone 5s and iPad Air 2 manage 120 fps). Slo-Mo makes everyday things like butterfly wing flaps and hair flips even more compelling.

In the Camera app, switch to the Slo-Mo mode; recording the video is the same as recording a regular video. On the iPhone 6 and iPhone 6 Plus, you can choose to record in 240 fps or 120 fps by tapping the number on the screen (1.16).

▶ **TIP** Slo-Mo videos shoot at a lower resolution than regular videos, 720p (1280 by 720 pixels), to record so many frames. The tradeoff is worth it.

1.16 Change the Slo-Mo speed on the iPhone 6 and iPhone 6 Plus.

Speed indicator (iPhone 6/6 Plus)

Dashed ring is a reminder you're in Slo-Mo mode.

When you play the Slo-Mo video, the Photos app automatically runs it in normal time at first, then transitions to slow-motion, and finally wraps up in normal time again. You can choose where the transitions occur by doing the following:

1. After recording the Slo-Mo video, tap the thumbnail in the Camera app to review it, or open the Photos app and tap the clip.

2. At the top of the screen, below the frame viewer, is a control that represents the speed. Drag the black vertical bars to frame the slow-motion portion of the video (represented by tickmarks spaced farther apart) (1.17).

3. Tap the Play button to review the changes.

A Slo-Mo video can have only one slow section; if you want to adjust the speed of multiple sections, you'll need to do that in a tool such as iMovie.

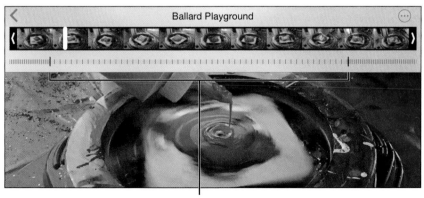

1.17 Set the slow-motion portion of the Slo-Mo video.

Drag handles to define slo-motion section.

Shoot a Time-Lapse Video

Another method of shifting time for your own ends is to shoot a time-lapse video. Instead of recording hundreds of frames per second, the Time-Lapse mode takes a still photo every few seconds over a long period of time, resulting in a sped-up video that compresses time.

Set the iPhone or iPad on a tripod or some other sturdy location, switch to the Time-Lapse mode, and tap the Record button (1.18).

1.18 Recording a time-lapse video

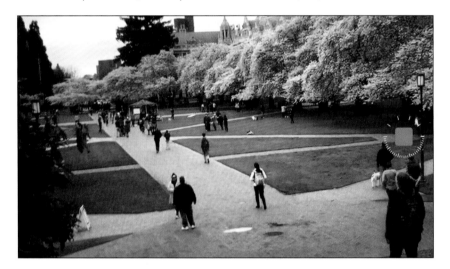

▶ **TIP** Just how often does the Camera app record frames for time-lapse movies? It turns out Apple is being clever. The app "snap(s) photos at dynamically selected intervals," which turns out to vary based on how long you record. As explained by Dan Provost of Studio Neat, a company that makes an app called Frameographer, the longer the recording time for the video, the fewer number of frames Apple records. For example, recording for less than 10 minutes yields 2 frames saved every second, while recording for up to 80 minutes yields 1 frame every 4 seconds. The result: a movie that runs between 20 and 40 seconds, with action happening faster the longer the recording duration, and played back at a smooth 30 fps. (See Provost's write up here: http://www.studioneat.com/blogs/main/15467765-how-does-the-ios-8-time-lapse-feature-work.)

Shoot Using Other Apps

Apple's approach has always been simplicity and an appeal to the most people it can reach. That leaves plenty of room for other developers to create photo apps with particular strengths. And believe me, there are a lot to choose from at the App Store. Here are a few that are worth checking out:

- **Camera+:** This app was one of the early apps to extend the photo-capture capabilities of the iPhone. It includes a host of features, like a horizontal level and white balance presets, but the one that grabbed my interest initially was the ability to set separate focus and exposure spots (1.19). (http://campl.us)

1.19 Camera+

- **Manual:** So you'd prefer not to let the computer do the thinking for you? Manual exposes the photo settings that give you control over your shots. Set shutter speed, ISO, focus, and white balance yourself (1.20, next page). The one control you can't access is aperture, because the iPhone's fixed lens is set at a maximum f/2.2 (or f/2.4 on the iPad Air 2). (http://shootmanual.co)

1.20 Manual

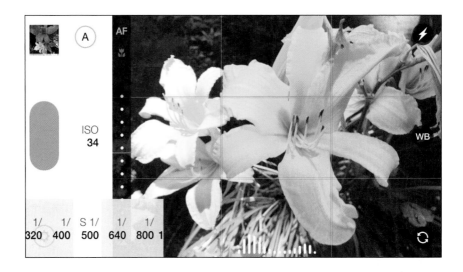

- **645 Pro Mk III:** I'm sorry, did I imply that Manual gave you all the control you wanted? 645 Pro Mk III is the app version of the photographer who can name every item in your local photography store (1.21). It has manual controls, simulated film stocks and filters (not the Instagram-style filters, but the glass ones you affix to the lens of a DSLR), and more. (http://jag.gr/645pro/)

1.21 645 Pro Mk III

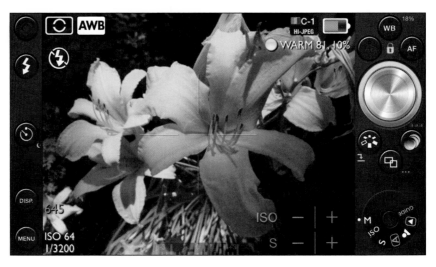

- **Hydra:** Creaceed, the creators of this app, decided to focus on a few specialized features for capturing photos instead of trying to reinvent an overall camera. Hydra blends multiple exposures to build HDR photos and videos, ensure better low-light photos and zoomed-in shots, and even create high-resolution 32 megapixel images (1.22). (http://www.creaceed.com/ihydra)

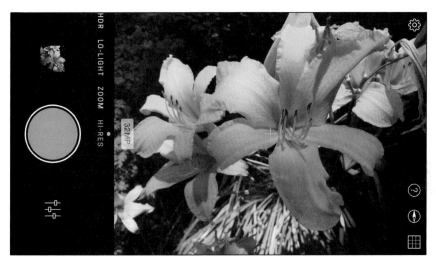

1.22 Hydra

Convert iPhoto and Aperture Libraries

Photos for OS X replaces both iPhoto and Aperture. Although each application will continue to work for a while, App won't release any more updates other than to fix egregious bugs I suspect that within a year or two the applications will no longer work at all. So what happens to the thousands of photos current stored in their libraries?

The good news is that the Photos application offers a direct path for each application. It will open the libraries directly, with very little trouble involved. In fact, you'll still be able to open the libraries in iPhoto or Aperture even after you've switched to Photos, (although you won't want to, as I describe shortly). However, doi so involves a number of tradeoffs, particularly if you use Apertur

Before you convert your current libraries to Photos, take a spin through this chapter for important tips on how to prepare and ea the transition. If you're starting fresh, skip ahead to Chapter 3.

This is where I get to play professional nag (in a friendly way) and ask, "You *do* have a current backup strategy, right?" Backups are important for keeping your computer's data safe, and for recovering quickly after a setback like a failed hard disk, but they're essential when it comes to digital photos. If the image files on your computer don't exist anywhere else, you could lose them all, forever, in a few seconds. Trust me, I've sat helpless as hard disks self-destructed next to me—even once when I did not have a good backup. It's terrifying.

I'll assume you're nodding along, so here's the first step in the conversion process: Make sure your iPhoto and Aperture library backups are up to date. Both applications store the libraries in the Pictures folder located in your Home folder (in the Finder, choose Go > Home, and then open the Pictures folder). There, you'll find one or both of the following files, depending on the application you own (2.1):

- **iPhoto:** iPhoto Library.photolibrary

- **Aperture:** Aperture Library.aplibrary

Photo and
ture libraries.
Mac may not
 the filename
nsion after the
d.

Drag that library file to an external hard drive to make a copy; or, hold Option and drag it to another location on your hard disk to make a copy.

▶ **NOTE** Each one is actually a special type of file called a *package*, which is essentially a folder that looks like a file. Inside the package are the database that keeps track of everything, the photos themselves, and related

Although OS X's Time Machine feature does back up your data, I recommend also making standalone copies of your libraries. In the unlikely event that something goes wrong during conversion, it's easier to replace a photo library from a spare copy than from Time Machine.

Verify and Troubleshoot Libraries

When it comes to photo libraries, I tend to take an abundance of caution (as you can tell). With so many hundreds or thousands of photos, it's almost impossible to see if something got missed or, worse, if something is corrupted. At their cores, iPhoto, Aperture, and Photos are databases that keep track of your photos. Apple built diagnostic tools that you can use to check things out if you notice something isn't working correctly (such as mangled photo previews).

Before converting a library to Photos, even if iPhoto or Aperture are running fine, I recommend running two diagnostic steps to help ensure that Photos starts on solid footing. The first is to make sure the library has the correct system-level permissions set—permissions are what dictate which actions the operating system can take. Second, validate and repair the integrity of the database. Both steps are easy to do, even if the mechanisms are a bit hidden.

1. In iPhoto or Aperture, open the application and immediately hold the Command and Option keys to bring up the Photo Library First Aid dialog (2.2).

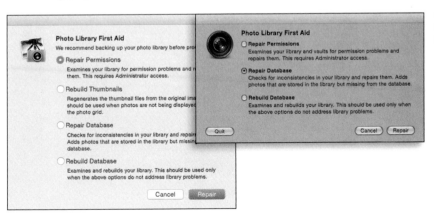

2.2 Photo Library First Aid in iPhoto and Aperture

2. Select the first item, Repair Permissions, and click the Repair button. After a short while, depending on the size of your library, the repair process ends and you can view your library.

3. Quit the application.

4. Open the app again, holding Command-Option to access the Photo Library First Aid dialog.

5. Select Repair Database and click the Repair button.

iPhoto includes an extra item, Rebuild Thumbnails, which is useful if iPhoto isn't displaying all the image previews. However, you can ignore it in this case because Photos for OS X builds its own thumbnails (and does it better and faster than iPhoto).

The final option in both applications, Rebuild Database, is overkill in preparation for moving to Photos unless you're having serious stability problems. Depending on the size of your library, rebuilding can take a long time.

Merge Libraries

Is your "photo library" actually a scattered armada of smaller libraries you've created over the years? Perhaps you ran out of storage space on a hard disk, or you created new iPhoto libraries for special events. iPhoto and Photos for OS X offer no way to merge libraries into one master library, but you can do it in Aperture or using an application called iPhoto Library Manager. Combining libraries is best done before opening them in Photos for OS X; the developer of iPhoto Library Manager has released a new application for Photos, called PowerPhotos, but it doesn't yet offer a merge feature.

If you choose not to merge libraries at this point, that's fine—you may just want to get to Photos already without these interruptions. There is a way to do it later in Photos using iCloud Photo Library, but it's not as elegant (see Chapter 3).

Merge libraries using iPhoto Library Manager

Fat Cat Software's iPhoto Library Manager ($30) is like a wishlist of basic features Apple never implemented in iPhoto. It makes it easier to work with multiple libraries (by not having to hold Option at startup), finds and removes duplicate photos, and merges libraries. Here's how to do the latter.

1. In iPhoto Library Manager, click the Merge Libraries button in the toolbar.

2. Choose a source library—the photos you want to add to your master library—and drag it to the Choose Source Libraries pane (2.3). Repeat if you want to incorporate other libraries.

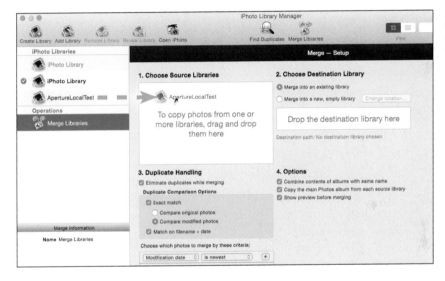

2.3 Choosing a source library to merge in iPhoto Library Manager

3. Drag your main library—the one that will receive the merged photos—to the Choose Destination Library pane.

4. Under Duplicate Handling, choose whether the program should find and eliminate duplicates.

5. In the Options section, click the Show Preview Before Merging check-box to see what will happen during the merge. That also allows you to act on any duplicates that crop up (2.4, on the next page).

2.4 Duplicates are identified so you can choose which version to keep in the merged library.

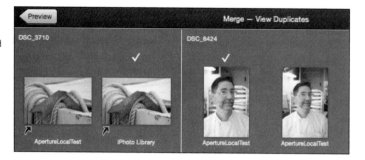

6. Click the Preview button to review the new library.

7. If everything looks good, click Merge to combine the libraries.

Merge libraries using Aperture

Although iPhoto and Aperture share the same file format, only Aperture includes a method of importing the contents of other libraries from either application. It doesn't search for duplicates the way iPhoto Library Manager does, though.

1. In Aperture, open the library you wish to use as your master. Choose File > Switch to Library if necessary to load the correct one.

2. Choose File > Import > Library **(2.5)**.

3. In the dialog that appears, locate the library file that contains the photos you want to add, and click Import. The photos are copied (not moved, so make sure you have enough free storage to accommodate) to your open library.

2.5 Aperture's Import Library feature

What Changes in Photos for OS X

There's one last topic to cover before opening an iPhoto or Aperture library in Photos for OS X. The new application looks and acts a bit different in practice, which I'll detail in the next chapter, but it also does a few notable things during the conversion process. Before you open an existing library in Photos, skim the following items for an important heads-up.

Star ratings are gone

I use star ratings all the time to note which of my photos are better than others, which ones I want to edit further, and which ones should just fade into obscurity. In Photos for OS X, you can mark an image only as a favorite or not.

That doesn't mean ratings completely disappear, however. Photos for OS X converts them to keywords instead. So, for example, a photo marked with three stars in iPhoto is tagged with the "3 star" keyword in Photos (2.6). Any smart albums that filter for star ratings pick up the new keyword instead. (In Chapter 3, I share a way to continue using star ratings, in case you're not ready to dispense with them. Personally, I find ratings to be quite valuable when evaluating and editing hundreds or thousands of photos at a time.)

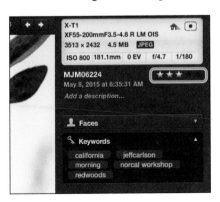
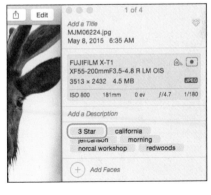

2.6 Star ratings in iPhoto (left) and Aperture become keywords in Photos (right).

Events and Projects become albums

Apple introduced Events in iPhoto to break up the tyranny of the seemingly endless scroll through all your photos. Photos for OS X continues that tradition by splitting photos into Collections and Moments, but what about Events? You'll find them converted to albums. And just to make things confusing, the albums are nested within a folder (that looks like an album) called iPhoto Events (2.7). Double-click that item to reveal your Events. Alas, the convenient trick of moving the mouse pointer over the album name does not reveal thumbnails of the album's contents, as in iPhoto.

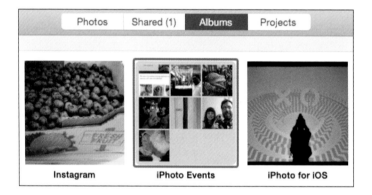

When migrating from Aperture, Projects are brought over, but they also appear in the folder called iPhoto Events.

Faces are now found in albums

The Faces feature, which identifies people in your photos, is still present in Photos for OS X, though it's not as prominent. Instead of being a top-level feature, Faces now appears as an album (2.8).

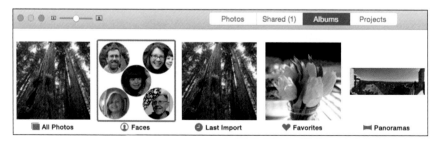

Some metadata is not visible

This limitation is likely to hit Aperture users harder than iPhoto users, and I'm hoping a fix will be added in an upcoming revision of Photos. In addition to the metadata that each camera adds to a photo—such as shutter speed, aperture, and focal length—an image can contain plenty of other information. Aperture provides a way to also include IPTC (International Press Telecommunications Council) data like your name, contact information, and copyright notice on each photo.

In Photos for OS X, that information still resides with the photo, but it's not exposed in the application's interface. You can still see the basic image data in the Information window, but not IPTC data.

▶ **TIP** If you ever need to check the IPTC information for a photo, open it in the Preview app, choose Tools > Show Inspector, click the More Info tab (❶), and then click the IPTC tab below it (**2.9**).

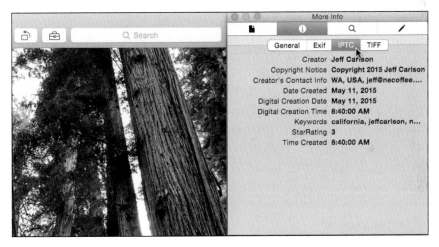

2.9 Reveal IPTC metadata in the Preview application.

Aperture custom fields are discarded

In Aperture, you can create custom metadata fields; for example, a company may use an internal tracking scheme for identifying photos. (In the Info inspector, click the settings button—with the gear icon—and choose Manage Custom Fields.) When converted to Photos for OS X, that information is ignored and does not transfer.

iPhoto referenced files actually work

You may never have run into this issue, but it was a long-running frustration of mine. iPhoto and Aperture (and Photos) prefer to keep all your photos within the library package file, the better to keep track of everything. But as your library grows, it can be difficult to fit everything onto a single hard disk. iPhoto and Aperture both offer the ability to reference photos from anywhere, such as on an external drive (in iPhoto's Advanced preferences, turn off the option to copy items to the iPhoto library; Aperture lets you specify a destination during import).

In iPhoto, however, if that external drive wasn't attached to the computer, you'd see a giant warning sign instead of the referenced photo. Photos for OS X correctly handles referenced files by showing a preview of the image, even if it's not currently online, with an icon in the lower-left corner to indicate its status (2.10).

(It's possible to consolidate a referenced library so all of its photos are in the package file; I explain how in Chapter 3.)

2.10 Referenced photo online (left) and the same photo when the drive on which it's located is unavailable (right)

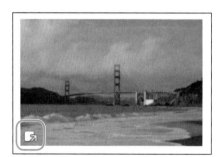 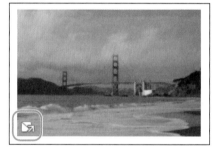

Migrate a Library to Photos for OS X

Now that you have a grasp of what will change afterwards, actually opening an iPhoto or Aperture library in Photos for OS X may be anticlimactic. The application handles all the conversion. The most taxing part of the process for you will likely be the amount of time you wait while the library is being prepared, depending on its size (let large libraries run overnight).

- If this is the first time you've launched Photos for OS X and it asks if you want to use iCloud Photo Library, I recommend clicking Not Now for the time being. I cover that feature in more detail in Chapter 3; it's easy to enable it later.

 Photos looks for a default library in your Pictures folder and opens it. If multiple libraries are found on the Mac, it asks you to choose one (2.11). Select it and click Choose Library, or click Other Library if the one you want isn't listed.

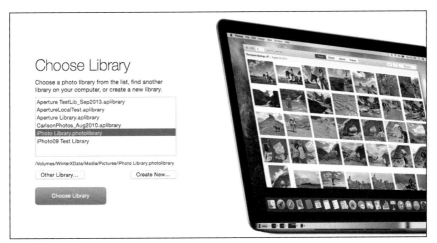

2.11 Choose a library if more than one exists on your Mac.

- If you have opened Photos previously but want to convert a different library, launch the application with the Option key held to bring up the Choose Library dialog, select the one you want, and click the Choose Library button (2.12).

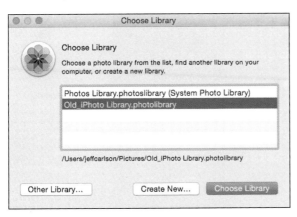

2.12 Access the Choose Library dialog any time you open Photos.

After the library is opened in Photos, you'll find two files: the original, which now has the extension ".migratedphotolibrary," and the new Photos library, with the extension ".photoslibrary" (2.13). (If you don't see the filename extension, go to the Finder menu, choose Preferences, click the Advanced button, and enable the Show All Filename Extensions checkbox.)

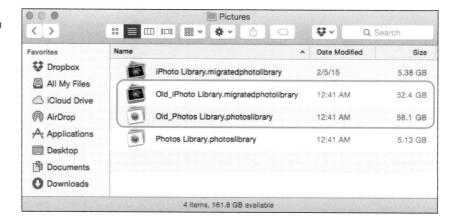

2.13 Converted photo libraries along with their originals

> ▶ **NOTE** At first glance, it looks as if Photos has duplicated all your photographs and gobbled valuable storage space. Don't worry, there's just one copy of your library! Due to the way Photos links to the images (called *hard links*) in the old library, the Finder incorrectly reports excessive storage being used. For a more technical explanation, see Jason Snell's article "The (hard) link between Photos and iPhoto" (http://sixcolors.com/post/2015/02/the-hard-link-between-photos-and-iphoto/).

Opening Converted Libraries in iPhoto or Aperture

Although iPhoto and Aperture are no longer being updated by Apple, not everyone is ready to move to Photos for OS X right away. So, even if you've converted a library to the new application, iPhoto and Aperture can still open the library.

But you don't want to. Any changes you make—edits, ratings, keywords—*do not* carry over to Photos, because the new software tracks edits and metadata differently than the old. (Similarly, any edits you make in Photos won't appear in iPhoto or Aperture.) If you do open a converted library in iPhoto or Aperture, the Mac presents a dialog asking if you really want to continue (**2.14**).

If you decide you want to stick with the oldies for a while longer on one of your libraries, delete the library file that Photos created (ending in ".photoslibrary"), and make sure you open the original in iPhoto or Aperture.

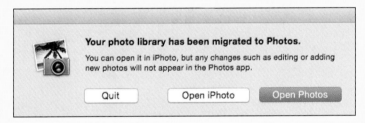

Your photo library has been migrated to Photos.

You can open it in iPhoto, but any changes such as editing or adding new photos will not appear in the Photos app.

| Quit | Open iPhoto | Open Photos |

2.14 Choose wisely when opening a library in iPhoto or Aperture.

CHAPTER 3

Your Photo Library

Photo editing gets all the attention, but at its heart the Photos app is a place to collect all your photos into a single place. Having a unified library makes it easy to grab photos to edit, of course, but there's more to it than that.

The library gives order to your thousands of images, removing the need for you to track it all in folders on your Mac. Since the photos are all digital files, you can add important information to them, such as the identities of people that appear in the shots and keywords that describe what's depicted. That data joins a host of other information that lives in the files.

And what do you do with all that information? Mark favorites, locate photos in albums and smart albums, and use the search feature to ultimately spend less time digging through your photos and more time enjoying the ones you want to see.

View and Navigate Photos

The Photos apps on the Mac and on iOS devices share the same scheme for organizing your photos, which makes it easy to jump between the two. However, it can be a bit bewildering at first. Roughly speaking, in the main Photos view, images are organized based on time, with the additional ability to view locations. You can also view photos in the Albums view (in which the images are organized by time).

View by time

The Photos approach is to initially show you photo thumbnails at a size at which the contents are easy to identify, with the option to "zoom out" to view more, smaller thumbnails that represent greater blocks of time (3.1).

- **Moments** reveals photos in smaller chunks based on time and location.

- **Collections** shows you photos grouped into horizontal blocks by date, usually a few days in each block. Collections are the closest analogue to events in iPhoto.

- **Years** groups photos based on the year they were shot.

▶ **TIP** Even though the Years and Collections views use smaller thumbnails, you can preview photos without jumping back and forth to the Moments view (which includes a slider for resizing the thumbnails). On the Mac, click and hold on a thumbnail to view a larger version of it; continue holding the mouse button and drag to view other thumbnails. When you release the mouse, the last photo you previewed opens. On iOS devices, touch and hold to do the same thing.

Switching between views is done by tapping or clicking a control at the top of the screen.

In Photos for iOS, the current view appears at the top of the screen. Tap the word at the upper-left corner to navigate to that view (3.2).

▶ **TIP** If, by chance, you are coming to the Photos app completely fresh and are faced with an empty library, skip ahead to "Import Photos" in this chapter to learn how to start populating the library. (And then come back here.)

3.1 Top to bottom: Moments, Collections, and Years

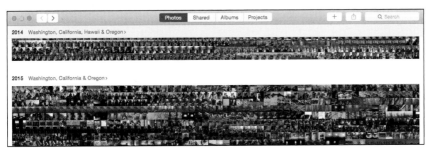

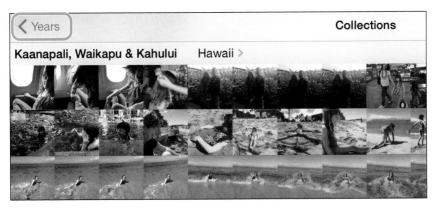

3.2 Navigate views in Photos for iOS (iPad shown here).

In Photos for OS X, click the navigation buttons in the upper-left corner (3.3). (If you hold over the button for a moment, a tooltip tells you where the button will take you.) The left button zooms out to the Years view; the right button zooms in to the Moments view.

3.3 Navigate views in Photos for OS X.

In both environments, the most recent photos appear at the bottom of the list; the oldest are at the top.

▶ **TIP** On iOS, tap the menu bar to scroll to the top of the current view. To jump down to the most recent photos, tap the Photos button at the bottom of the screen (or the Shared or Albums buttons if you're navigating one of those views).

Summarize Photos

When you switch to the Years and Collections views, you may notice that not all of your photos are represented by thumbnails. Did the Photos app lose track of them? Nope, it's just trying to be helpful (and speedy).

Both views draw faster when there are fewer thumbnails to reproduce, and since the Years view especially is intended as a broad starting place, the application includes a representative sample of images. You can turn off this option and see everything if you'd like: Open the Photos app's preferences (choose Photos > Preferences, or press Command-, [comma]), click the General button, and turn off the Summarize Photos option.

This control is found in Photos for iOS, too: Go to Settings > Photos & Camera and turn off Summarize Photos under Photos Tab.

To view a single photo (3.4), double-click it in any view in Photos for OS X, or, in iOS, tap it from the Moments view.

You can zoom in on the image on the Mac by dragging the size slider or using gestures (see the sidebar below). To go to the previous or next photo without returning to the Moments view, press the left or right arrow keys on your keyboard.

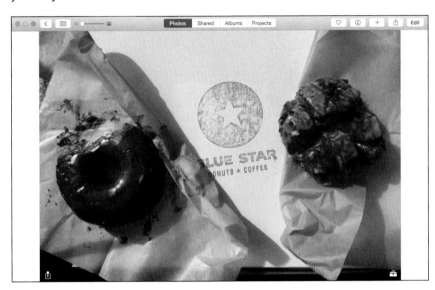

3.4 Viewing a single photo on the Mac (and delivering a public service announcement: When in Portland, Oregon, go to Blue Star for donuts instead of to the touristy alternative you've probably heard more about).

Trackpad Navigation on the Mac

If you use a laptop's trackpad or a Magic Trackpad connected to your Mac, you can navigate without reaching for the buttons at the top of the screen.

- Pinch with two fingers to switch between the Photos tab views: pinch outward to zoom in toward the Moments view; pinch inward to zoom out to the Years view.

- In any view, double-tap a thumbnail to open that image directly.

- When viewing a photo, double-tap with two fingers to zoom in to the image.

- Swipe sideways with two fingers to view the previous or next photo.

- Also when viewing a single photo, pinch inward to return to the Moments view (this gesture is also used on iOS).

When viewing a single photo, the image occupies most of the Photos interface. You can also display thumbnails of other images within the same moment by clicking the Split View button or choosing View > Show Split View (3.5). Normally the thumbnails are square, but you can opt to show the images in their actual aspect ratios by choosing View > Display Square Thumbnails in Split View to toggle the setting off.

To further arrange the split view to your liking, drag the border between the image and the thumbnails to increase or decrease the number of columns that are shown (3.6).

Split View button

3.5 The split view helps you choose photos within the same moment.

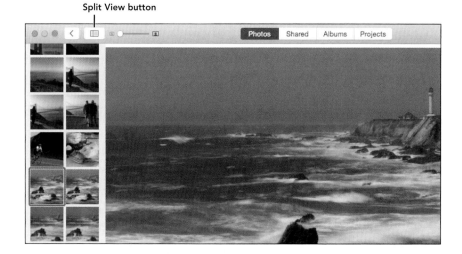

3.6 Resize the split view.

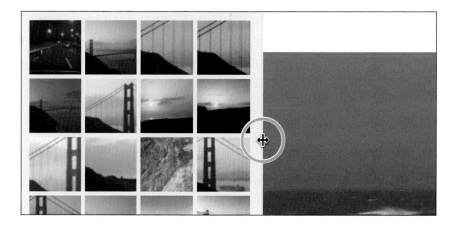

Still Miss iPhoto? Turn On the Sidebar

The new method of navigating your photo library is definitely a departure from what you were accustomed to in iPhoto or Aperture. Photos for OS X has a feature you may appreciate: choose View > Show Sidebar (or press Command-Option-S) **(3.7)**. You'll notice a few changes:

- The navigation tabs at the top of the window (Photos, Shared, Albums, and Projects) go away.

- The main Photos view persists (incorporating Moments, Collections, and Years), but appears as the top item in the sidebar.

- Shared albums and local albums appear in the sidebar list. You can hide the items by clicking the Hide button that appears when you position the mouse pointer next to the category name.

- If you frequently access the smart albums that Photos creates, such as Favorites or Panoramas, making the sidebar visible saves you a click: select the album in the sidebar instead of first clicking the Albums tab and then clicking the album you want.

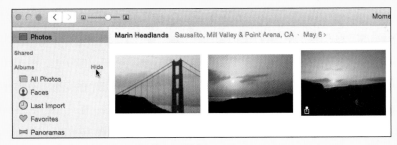

3.7 A bit of iPhoto lives on in the Photos sidebar.

View locations

Whenever your iPhone takes a photo, the GPS coordinates are added to the image file. No longer do you need to wonder where you captured a shot—just look in the Photos app (on OS X and iOS). That said, it's not obvious at first just how to view that information.

In any of the three main views (Moments, Collections, or Years), a place name (or several) appears at the top of each group (3.8). Click it to reveal a map with thumbnails at the locations where the geotagged photos were taken (3.9).

When you zoom in to the map, the locations become more specific. Clicking a thumbnail group (indicated by a number badge for how many photos are at that location) opens a window containing those photos; clicking a single image opens the photo.

3.8 Accessing location data is almost too subtle; Photos for OS X shown here, but the same control appears in Photos for iOS.

3.9 Photos appear where they were taken.

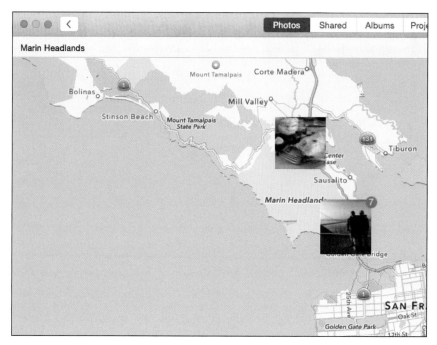

Choose between Standard, Satellite, and Hybrid renderings, and pan, zoom, and tilt the map to get different views of locations. Use the navigation controls at the lower-right corner of the window (3.10), use gestures on a trackpad, or use keyboard shortcuts combined with mouse clicks to navigate a map:

- Hold Shift and drag up or down to zoom in or out.

- Hold Option and drag up or down to tilt the map into 3D mode. Some views don't support 3D maps.

- Hold Option and drag left or right to rotate the map around the spot where you clicked.

Click the 3D button in the middle to re-orient the map to due north.

3.10 Map navigation controls

Another way to view location information in Photos for OS X is in the Info window. Choose Window > Info to display the floating Info window. If any photos in the current view include location information, they appear as pins on a small map (3.11). When you view a single photo, its location shows up along with its other information.

Unfortunately, the Info window is just a reference: you can zoom in and out of the mini-map, but clicking the pins doesn't take you to the photos shot at that location, as you might expect.

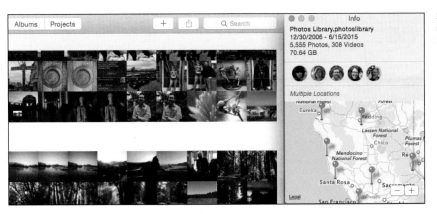

3.11 Locations mapped in the Info window

Adding Location Information to Photos

Unfortunately, in the initial version of Photos for OS X there's no way to add location information to photos that don't already have it. That feature will come when Apple releases the next version of the operating system, OS X El Capitan, in fall 2015. For now, you need a third-party app such as HoudahGeo (www.houdah.com/houdahGeo/) or Photo GeoTag (geotag.modesittsoftware.com). Import your photos into one of those apps before bringing them to Photos for OS X, apply the geographic data to the shots, and then import the newly tagged images into the Photos app. (I cover importing just ahead.)

View by Albums

Click the Albums tab in Photos for OS X to view the smart albums that Apple creates (such as All Photos, Last Import, and Favorites) as well as any albums or smart albums that you create (3.12). Double-click an album's thumbnail to open it. (See "Albums," later in this chapter, for more on creating and editing albums.)

If you've turned on the sidebar, your albums are listed there; a single click on one selects it and displays its contents.

3.12 The contents of the Albums tab in Photos for OS X

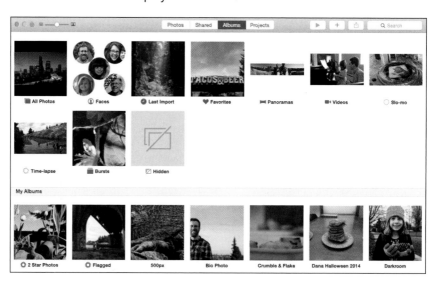

On the iPhone and iPad, tap the Albums button at the bottom of the screen to view the same groupings (3.13). Tap an album to view its contents.

▶ **TIP** Apple's automatic smart albums appear only when needed. If you have no panoramas in your library, for example, that smart album doesn't show up. Also, since the iOS version of Photos doesn't support the Faces feature found in Photos for OS X, you won't see a Faces album on mobile devices.

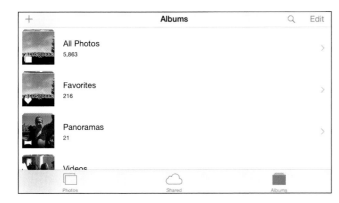

3.13 The Photos app on the iPhone, shown here, groups albums in their own screen.

When you're viewing an album, the navigation buttons change to a single back button that takes you back to the Albums screen (3.14).

▶ **TIP** You may see a Camera Roll album on your Mac or iOS device, which isn't included in the two figures here. The Camera Roll is the destination for photos you take with the iPhone or iPad's camera, or photos you import directly to an iOS device by other means. The Camera Roll doesn't appear here because iCloud Photo Library is enabled—the Camera Roll is replaced by All Photos. See "iCloud Photo Library," later in this chapter, for more on Apple's cloud service.

3.14 Click the back button to return to the Albums screen.

Import Photos

The first step toward organizing and editing new photos is to import them into the Photos app. Most likely this will be from a camera or a memory card, but Photos can also import photos that are on your hard disk. (If you're looking to bring in photos from an iPhoto or Aperture library, see Chapter 2.) It's also possible to import photos directly to an iPad.

Import from a camera or a memory card

Connect your camera via a USB cable, or pop out its memory card and insert that into a reader so the Mac can read it. From there, do the following:

1. In Photos, a new Import tab appears at the top of the screen; click it to view the contents of the camera or card (3.15). If, instead, the sidebar is visible, look for the name of the camera or card under Import.

 You may need to power on the camera or switch to its reviewing mode. Also, when you connect the camera, Photos may automatically switch to the Import tab.

 Feel free to adjust the thumbnail size slider to get a better look at your photos.

3.15 The Import interface

▶ **NOTE** The photos above include a badge marked "J" in the corner. That indicates two things: my camera was in Raw+JPEG mode, which captures both a raw and a JPEG version of each shot. The "J" indicates that I'm viewing the JPEG portion of the pair. This feature becomes more important when editing the shots; see Chapter 5 for more information.

▶ **NOTE** If you're not using iCloud Photo Library or My Photo Stream to sync photos from an iPhone or iPad, connect the device to your Mac using its sync cable. The Photos app sees the device as a camera, enabling you to import the photos just as if it were any other camera.

2. Ensure that the "Delete items after import" checkbox is not selected. Call me paranoid, but I prefer to erase the memory card within the camera later, after I'm certain everything has imported successfully.

3. To import all the photos on the card, click the Import All New Photos button.

 To import just some of the photos, click to select the items you want; you can also Shift-click or click-and-drag to select multiple images quickly. Then, click the Import Selected button to copy the image files.

 If you've previous added photos from this source, those images are recognized as Already Imported (3.16).

3.16 Previously imported photos are held aside to prevent duplicates during import.

A small progress wheel appears to give you an idea of how much of the import has completed (3.17). The images are copied to your library, and then show up in the Last Import album. If you need to cancel the import, click the progress wheel and then click the X button.

3.17 Are we there yet? Is it done? Huh? Huh? Is it?

▶ **TIP** Your Mac will recognize a memory card or camera the next time it's connected, and can automatically open Photos. If you'd prefer not to launch the application each time, turn off the "Open photos for this device" option at the top of the Import window.

Import from the hard disk

Images can come from other sources besides directly from a camera. To import photos stored on your Mac's hard disk, or perhaps on an attached USB drive, do this:

1. Choose File > Import, or press Command-Shift-I.

2. In the dialog that appears, navigate to the folder containing the images you want to import (3.18).

3. Click the Review for Import button. The same interface for importing photos from the camera appears.

4. Click Import All Photos to grab everything, or select the images you want and click Import Selected.

3.18 Import image files from the hard disk

▶ **TIP** To speed up the import process, hold Option when you choose File > Import, which changes the command to Import without Review. After you navigate to the folder you want, Photos adds the images without going through the standard Import interface.

▶ **TIP** For an even faster method of importing the photos, simply drag the image files from the Finder to the Photos window.

Import photos without moving their files

When you import photos from a camera or memory card, the image files are copied to the library file that Photos opens. (The file is actually a special folder called a *package*, which stores the images, thumbnails, and the database that keeps track of everything.) A problem with this approach is that your hard disk can quickly fill up—especially smaller-capacity solid-state drives. The alternative is to store files in a separate location, such as an external hard disk, and make sure Photos doesn't move them when you import them.

▶ **TIP** This setting applies only to images imported from the hard disk. Since photos coming from the camera or a memory card need a home on disk, the library's location is the destination, so this option doesn't apply to those imports.

To do this, go to the Photos preferences and, in the General tab, turn off the Copy Items to Library setting. An icon on the thumbnails indicates which photos are stored outside the library file (3.19).

3.19 Referenced photos, as indicated by this icon

Consolidate the library

The good news is that Photos keeps track of all your photos, even if they're not in the same location—and even if the drive they're on isn't currently connected (an inexcusable failing of iPhoto; see Chapter 2). However, if you want to bring photos under the same roof at some point, it's easy to do: Select the photos you want to copy to the library file, and choose File > Consolidate. The app reminds you that copying can't be undone; click Copy.

▶ **TIP** Consolidating the library is important for setting up iCloud Photo Library, since the service doesn't support referenced photos. See "iCloud Photo Library," later in this chapter.

Adjust the date and time

Have you ever traveled to a different time zone but forgot to change the date and time in your camera? You can easily fix that after you've imported your photos. Select the affected images and choose Image > Adjust Date and Time. In the dialog that appears, change the time, date, or both in the Adjusted field; or, in the world map, click the correct time zone. Click the Adjust button to apply the change.

Import into the Photos app on an iPad

There aren't as many options on the iOS side of the fence when it comes to importing photos—that's really the thrust of iCloud Photo Library and having all your devices synchronized via iCloud (see "iCloud Photo Library," later in this chapter). However, the iPad is able to import photos directly, using a camera adapter you can purchase separately.

This setup gives you the ability to view and share files when you're away from your Mac. If you're not syncing photos via iCloud, you can add the images to Photos for OS X later by connecting the iPad via its sync cable and importing them as if the iPad were a regular camera.

1. Connect the camera or card to the adapter, and then plug that into the iPad.

2. Open the Photos app and tap the Import button that appears at the bottom of the screen.

3. Tap the Import All button to copy everything available, or select the photos you want to add and tap the Import button; for the latter option, you're asked if you want to Import Selected or Import All **(3.20)**.

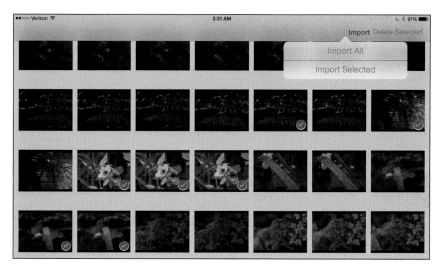

3.20 Import photos directly to an iPad.

▶ **NOTE** Other methods exist for importing photos to an iPad or an iPhone. Apps from camera manufacturers like Fuji, Nikon, and Canon can import images from cameras equipped with Wi-Fi (or that use wireless adapters). ShutterSnitch (shuttersnitch.com) can communicate with a variety of cameras, devices, and Wi-Fi–enabled memory cards (like EyeFi cards). In most cases, the images are saved to the Camera Roll; ShutterSnitch stores the photos in its own memory, but copies them to the Camera Roll when you're ready to export to your photo library.

▶ **NOTE** Allow a humble plug for another book of mine that's relevant in this situation: *The iPad for Photographers, Third Edition* tells you everything you need to know about using an iPad for photographic ends. It focuses on how the iPad can replace a laptop while you're in the field, editing on the device itself, controlling a camera remotely from the tablet, and more. You'll find it at your favorite bookstore, online bookseller, or from my site at ipadforphotographers.com.

Mark Favorites

Good photos always rise above mediocre ones, but how do you find them easily? In the Photos ecosystem, an image can be marked as a favorite. The next time you want to show some images to a friend or build a slideshow of standout photos, you can choose from the ones you've marked instead of slogging through the rest.

▶ **NOTE** As mentioned in Chapter 2, the Photos application abandons the star-rating system used by iPhoto and Aperture in favor of just the single Favorite designation. Keep reading to learn how to incorporate a similar rating system using keyword tags.

Marking a photo as a favorite (all heart icons) can be accomplished in several ways (3.21):

- In the Info window, click the Favorite button.

- With the photo viewed in single image mode, click the Favorite button on the toolbar.

- When viewing the thumbnail view of your library, click the Favorite button in the upper-left corner of a thumbnail.

- Press the period (.) key.

- On an iOS device, open a photo and tap the Favorite button at the top (iPad) or bottom (iPhone) of the screen.

Favorite (main window) Favorite (Info window)

3.21 Mark a photo as a favorite.

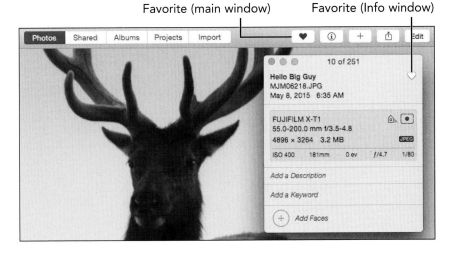

Add Information to Photos

When you capture a photo, the camera records a host of other information about the shot. This metadata ranges from the time and date you pressed the shutter button to the lens, aperture, shutter speed, and ISO in use for that image. Photos for OS X reveals this information in the Info window (3.22), accessible from the Window menu or by pressing Command-I.

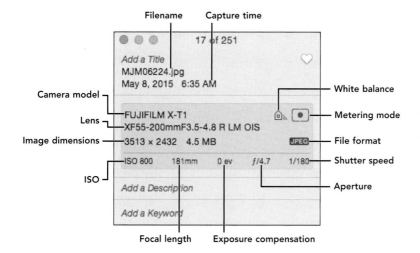

3.22 The Info window

Add a title and description

At import, each photo is known only by the name the camera gives it. You can add a name or a description (or both), which will appear when you share photos to social media sites (instead of displaying something like IMG_1234.JPG) and which will help you find the files in your library later. Do any of the following (3.23, **on the next page**):

* In the Info window, click the Add a Title field and type a title.

* Choose View > Metadata > Titles to reveal the Title field beneath each thumbnail, and type a title there. I like this option for titles because it doesn't require the Info window to be open all the time.

* Also in the Info window, click the Add a Description field and enter some descriptive text.

3.23 Add a title or
description to a photo.

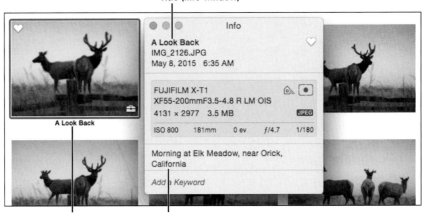

A Look Back

Title (thumbnail view) Description

Add keywords

Keywords are metadata that people rarely see, but they turn out to be
important behind the scenes. Adding keywords helps you locate photos
later—for example, a search for "elk" will bring up every photo containing
an elk. Also, many photo sharing sites use keywords to categorize images
and potentially lead buyers or licensors to photos that match their interests.

Keywords in the Info window

Select one or more photos. In the Info window, type keywords into the
Add a Keyword field, separating each one with a comma or by pressing
Return. Keywords can be anything you like, ranging from the contents of
the image ("elk," "meadow") to the type of image ("landscape," "wild-
life"). The Photos application adds them to the photo(s) and also to its
library of keywords so the next time you start to type one, it autocom-
pletes for you (3.24).

3.24 Type keywords
into the Info window.

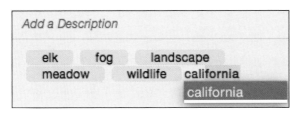

Keyword Manager

The Keyword Manager is a more visual approach to assigning keywords, and is useful when you'd prefer to choose existing keywords. Choose Window > Keyword Manager (or press Command-K) to view the window and all the keywords used in your photo library (3.25). Click a keyword button to apply it to the selected photo(s).

3.25 The Keyword Manager

Overall, I'm not a fan of the Keyword Manager, because it's really a cumbersome, old-fashioned way of adding and editing keywords. However, it does have an advantage: You can add frequently used keywords to the Quick Group, which assigns keyboard shortcuts to them for easy tagging.

Drag keywords to the Quick Group area; Photos automatically assigns a shortcut based on the first character of the keyword (3.26). (If a letter is already taken, Photos uses the next letter. So, "wildlife" would be W and "woods" would be O.)

3.26 The Quick Group

You can change the shortcut key by clicking Edit Keywords, selecting one of the terms, and clicking the Shortcut button. To remove a keyword from the Quick Group, drag it out of the Quick Group area.

To apply keywords using shortcuts, *make sure the Keyword Manager is open*, select the photos you want to tag, and then press the shortcut key. If the Keyword Manager isn't open, the shortcut keys don't work.

Photos with keywords applied gain a keyword badge (3.27).

3.27 Keyword badge

Replicate star ratings using keywords

This brings me to one of the most useful ways of using keywords, especially if you miss the ability in iPhoto and Aperture to apply star ratings to your photos. When you think about it, ratings are just another type of metadata…like keywords. When you convert an iPhoto or Aperture library to Photos (see Chapter 2), star ratings are automatically converted to keywords such as "1 Star."

The great advantage to using ratings in iPhoto and Aperture was how easy it was to apply them using keyboard shortcuts. By adding these faux star ratings to the Quick Group in Photos for OS X, you regain the ability to rate photos by simply pressing a key (3.28).

3.28 Star ratings, revived in Photos

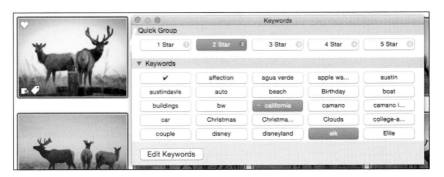

Hide and Delete Photos

It's time to own up to a common truth: Not all of our photos are great, or good, or even half-decent. For a long time I assumed that I'd reach a point where the misfires, the unfocused shots, and the plain ol' goofs would stop happening when I took photos, but that's just not the case. If anything, I think my good photos are better than the ones I thought were good years ago, but that still leaves a lot of room for flubs.

The Photos application, both on OS X and iOS, offers two actions to weed out the less-desirable shots—and interestingly, both leave the door open in case you think that maybe an action shot of your cat that's actually just a dark blur against a shaky background was what you wanted all along.

Hide photos

When you hide photos, they don't appear in the Years, Collections, and Moments views, but they still exist in your library.

- In the Moments view in Photos for OS X, select one or more photos and choose Image > Hide Photo (or press Command-L), or right-click the photo and choose Hide Photo from the contextual menu (3.29). Confirm that you want to hide the photo in the dialog that appears.

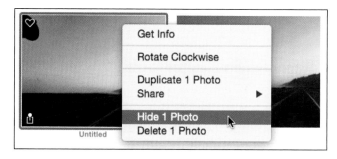

3.29 Hide a photo using the contextual menu.

▶ **NOTE** When I say that photos are hidden, what I mean is that they're "hidden." If a hidden photo is already in an album (including All Photos), or picked up by a smart album, it still shows up there. So be warned that "hiding" applies only to the Years, Collections, and Moments views.

- In the Moments view in Photos for iOS, touch and hold on a photo until you see the Hide option appear (3.30). Tap Hide and then confirm your action in the popup that appears.

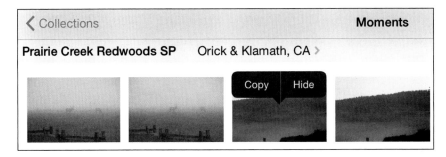

To view photos you've hidden, go to the Albums view and open the Hidden album. From there you can make hidden photos visible by choosing Unhide Photo from the Image menu or the contextual menu (OS X), or touching and holding a photo and choosing Unhide from the popup that appears (iOS).

Delete photos

To remove a photo from your library in Photos for OS X, select it in the Moments view and choose Image > Delete Photo (or press the Delete key), or right-click the image and choose Delete Photo from the contextual menu.

On the iPhone or iPad, do one of the following:

- Open a photo in the Moments view, tap the Delete button (the trash can), and confirm your action.

- To delete multiple photos, first tap the Select button at the upper-right corner, and then tap to select photos to be removed (3.31). In the Select mode you can also choose all photos in a moment by tapping the smaller Select button to the right. Tap the Delete button (the trash can) and confirm the deletion.

▶ **NOTE** If any of the photos you delete were pulled out from a burst, the original versions remain part of the burst.

3.31 Choosing multiple photos to delete on an iPhone

Recover deleted photos

So, it turns out that even deleted items aren't completely gone. The Photos app treats them as if they've been removed, but also stores them in a Recently Deleted album just in case you change your mind.

Deleted photos don't linger forever, though. Shots in the Recently Deleted album that are older than 30–40 days are automatically removed, and the rest appear with the number of days before they're sent to the bit compacter.

- In Photos for OS X, choose File > Show Recently Deleted (3.32). Although Recently Deleted is an album, on the Mac it's not listed with the other albums; you can view it only from the File menu. Select the photos you want to save and click the Recover button.

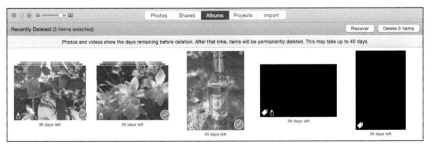

3.32 Recently deleted photos, with their expiration dates

- In Photos for iOS, tap the Albums button and then tap the Recently Deleted album to open it. Tap a photo to view it and then tap Recover; or, to recover multiple images at once, tap Select, choose the photos you want, and then tap the Recover button.

Delete photos permanently

Automatically expiring photos after 30 days is fine if you've got the room to spare, but what if you want to remove photos immediately? The Recently Deleted album includes another option: Select the photos you want to eradicate, and click the Delete Item button (OS X) or tap the Delete button (iOS). You can also click or tap the Delete All button to clear out everything in the album.

▶ **NOTE** When you have iCloud Photo Library enabled, recovering or permanently deleting photos from Recently Deleted applies the action to all computers and devices that share the library.

Albums and Smart Albums

Our photo libraries continue to grow, and automatically sorting them by date and location certainly helps to manage the volume. But those aren't the only options. Sometimes it's helpful to separate photos and videos into albums—or let the software do the work for us.

In Photos for OS X, you can create regular albums into which you manually add photos, as well as smart albums that display contents based on criteria you specify. On iOS, the Photos app supports regular albums but not user-created smart albums.

Create an album in Photos for OS X

Photos for OS X provides several ways to create a new album and add photos to it—the idea is that you should be able to do it nearly anywhere in the application, not just within the Albums view. Here's how:

1. In any view, and with no photos selected, choose File > New Album.

2. In the dialog that appears, make sure New Album is selected in the Album pop-up menu and enter a title in the Album Name field. Click OK.

3. Select some photos to add to the album (3.33). You can scroll through all photos to locate them, or click the Favorites button to browse photos you've marked as favorites. Click Add.

 The album is created with the selected images inside, and you're switched to the Albums view with that album open.

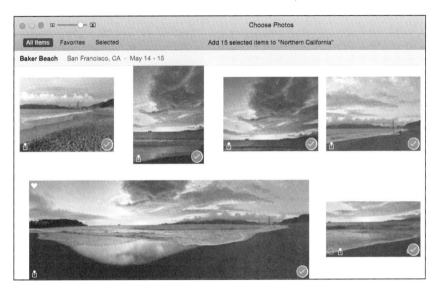

3.33 Add photos as you make a new album.

▶ **NOTE** You can also create an album without going through the steps of populating it right away. Choose File > New Empty Album, give it a name, and click OK. The empty album shows up in the Albums view.

A quicker method is to select the images you want to include in an album and then choose File > New Album. The album is created immediately with the images in place.

But wait, there's more! It's easy to turn a moment into a new album:

1. In the Moments or Collections views, click the Add button (+) to the right of the name of a moment or collection (3.34, on the next page).

2. Choose Album from the pop-up that appears.

3. In the dialog that appears, the location and date of the moment are used as the album name; change it if you wish. Click OK.

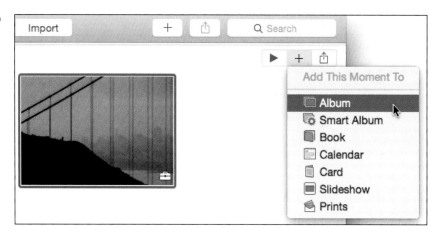

Folders and Albums

It's not immediately apparent, but you can collect albums into folders. For example, perhaps you'd like separate albums for sections of a vacation but to group them together in one place. Choose File > New Folder to create an empty folder in the Albums view (or the sidebar). Give it a name, and then drag albums into it. A folder appears with thumbnails for the albums within it, or as an expandable folder icon in the sidebar (3.35).

In Photos for iOS, folders look the same as in the Albums view on the Mac, but opening one reveals an All Photos option—you can view all the photos in the enclosed albums without switching between them.

To create a new folder in Photos for iOS, touch and hold the Add (+) button, and then choose New Folder from the options that appear.

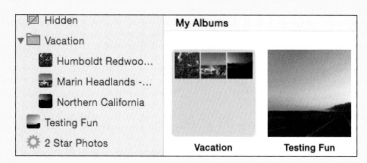

3.35 A folder, "Vacation," as it appears in the sidebar and in the Albums view

Add more photos to an album

When you want to add additional photos to an album, you can't just drag the images from one of the standard views to the album. Instead, you use the Add To mechanism:

1. Select the photos you want to add.

2. Click the Add button (+) in the toolbar and choose Album (3.36).

3. In the dialog that appears, click the Album pop-up and choose the destination album (3.37).

▶ **TIP** Did I say there was no way to drag photos to albums? Silly me, I forgot about the sidebar: drag images directly to albums in the sidebar.

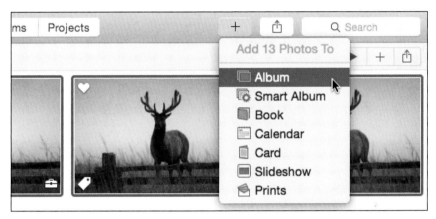

3.36 The first step to adding photos to an existing album

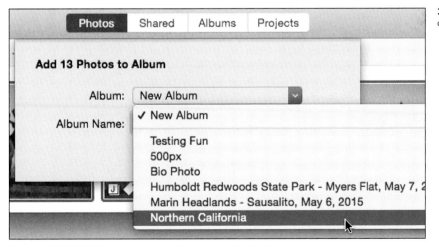

3.37 Choose the destination album.

Reorganize photos in an album

One advantage albums have over the standard views is the ability for you to arrange photos into whatever order you like. This option is great for playing spontaneous slideshows from albums, where you have a preference for the order the photos appear. Drag images to reorganize them (3.38).

Or, you can let the Photos app keep everything organized by choosing View > Keep Sorted by Date.

▶ **TIP** In the Albums view, you can also drag album icons to rearrange them. Or, in the sidebar, drag albums up or down in the list.

3.38 Arrange photos in an album.

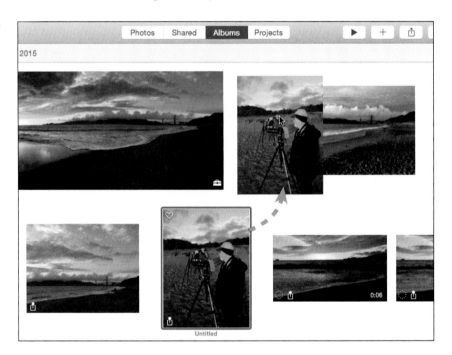

Choose an album's cover photo

Did Photos choose the most unflattering photo as the thumbnail for an album? Open the album and find an image you'd rather use; then, choose Image > Make Key Photo (or press Command-Shift-K). You can also right-click or Control-click the shot and choose Make Key Photo from the contextual menu (3.39).

Remove photos from an album

When you add photos to an album, the images aren't copied or moved anywhere; an album is simply an internal way of organizing images in the Photos application. So, when you remove a photo from an album, the image still exists in the library.

In an album, select the image(s) you want to remove and choose Image > Remove Photo(s) from Album, or press the Delete key. You can alternatively choose Remove from Album from the contextual menu.

▶ **NOTE** The Show in Moment command that appears under the Image menu and in the contextual menu takes you to the Moments view so you can browse the image with the other photos captured or imported at the same time.

Create an album in Photos for iOS

On the iPhone and iPad, the process of creating a new album is similar in spirit to how it's done on the Mac, but different in a few details.

1. In the Albums view, tap the Add button (+), enter a name for the album, and tap Save.

2. On the next screen, browse the Moments or Collections screen and select the photos you wish to add (3.40). You can also select entire moments to be added.

3. Tap Done to create the album with those photos included.

3.40 Creating a new album on an iPhone

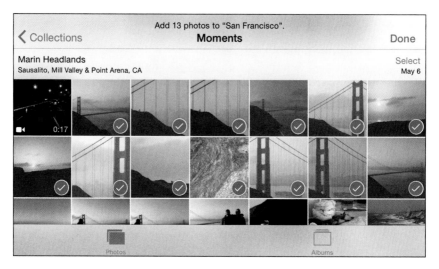

Just as with Photos for OS X, you can create an album by first selecting the photos you want to put in it.

1. In the Moments view, select the photos you want to add to the new album.

2. Tap the Add To button at the bottom of the screen.

3. In the Add to Album screen, scroll to the bottom of the album list and tap New Album (3.41).

4. Enter a name for the album and tap Save.

Add more photos to an album in Photos for iOS

As you can guess, the Add To route is also the way to add photos to an existing album: in step 3, choose an existing album instead of tapping New Album.

Or, when you're viewing the contents of an album, tap Select and then tap the Add button to select more photos to include in that album.

Add to Album	Cancel

57 Photos

Marin Headlands - Sausalito, May 6, 2015
32

San Francisco
13

New Album...

Apple's smart albums

A *smart album* is one that automatically grabs photos based on some criteria—you don't add photos manually at all. Since Apple provides several types of photos that aren't your standard still shots, the Photos app on both OS X and iOS includes smart albums for favorites, panoramas, burst shots, hidden items, videos, Slo-Mo videos, and time-lapse videos. You'll also find a special Last Import album and an All Photos album that collects everything. (Photos for OS X additionally has a Faces album, which is actually the portal for the Faces feature and behaves a bit differently than most albums. See "Identify Faces," later in this chapter.)

You'll find these in the Albums view.

▶ **TIP** A smart album appears only if that type of image is in your library. If you haven't made any panoramas, for example, you won't see the Panoramas album.

For the most part, the built-in smart albums merely collect these types of images to make them easier to find. One exception is the Bursts album, where you can extract single shots from the bursts, just as you can do on the iPhone or iPad. Here's how to do it in Photos for OS X:

1. In the Albums pane, open the Bursts smart album.

2. Double-click a burst to open it.

3. Click the Make a Selection button that appears in the upper-left corner (3.42).

3.42 The Make a Selection button

4. Click the thumbnails below the photo to view each image (3.43). The circle below the thumbnails is the one that the iPhone or iPad chose as the best of the bunch; the triangle indicates which image is currently being viewed.

3.43 Choose which images to keep.

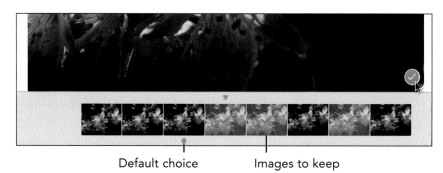

Default choice Images to keep

5. Click the image if it's one you want to extract; a blue checkmark appears in the lower-right corner.

6. Click the Done button.

7. In the dialog that appears, decide whether you want to keep all of the photos in the burst (Keep Everything), or keep just the selected shots and delete the others (Keep Only Selection) (3.44).

3.44 Decide whether or not to discard the other images in the burst.

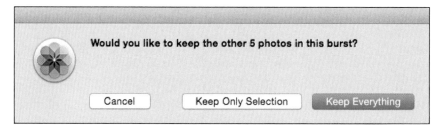

Create a smart album in Photos for OS X

The power of a smart album is that you can define all sorts of criteria beyond what Apple offers in its built-in smart albums. To throw out a few examples:

- Show all photos taken between July 1 and July 15.

- Show all photos marked as Favorite that also contain the keyword "landscape."

- Show all referenced photos.

- Show all photos captured using a Fuji X-T1 with aperture settings wider than f/2.8.

> ▶ **NOTE** Alas, the only smart albums that work in the Photos app on the iPhone and iPad are the built-in Apple ones. Smart albums you create on the Mac do not transfer to the mobile devices, and there's no feature for creating smart albums in Photos for iOS.

You get the idea. Now let's look at how to create a smart album. By way of example, let's create a smart album that finds the best photos captured in the past six months using a specific camera model:

1. Choose File > New Smart Album, or press Command-Option-N.

2. In the dialog that appears, enter a descriptive name in the Smart Album Name field (3.45).

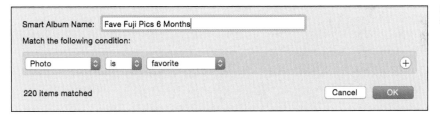

3.45 Name a new smart album.

3. Next, start defining the album's criteria; the default is "Photo is favorite," represented in three pop-up menus, so keep that.

 The first pop-up is the thing to which you want to match, like the photo, text, or a camera setting. The second pop-up is the action, such as "is," "is not," "includes," or "does not include." And the third pop-up describes the data that should be matched or ignored.

▶ **TIP** Notice that the filtering happens in real time: the lower-left corner of the dialog tells you how many photos match the current conditions.

4. Click the Add (+) button to the right of the criterion to add a new one. Not only does another set of pop-up menus appears, but a new Match condition shows up above the criteria **(3.46)**.

 The Match qualifier specifies that "any" or "all" of the conditions must be met to include an image in the smart album. In this example, choose "all" because we want only photos that are described by all of the conditions.

3.46 Add conditions to the smart album.

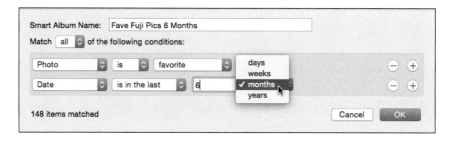

5. In the second condition, set it to "Date is in the last 6 months."

6. Click the Add (+) button next to the second condition to add a third.

7. Set the new condition to "Camera Model is" and choose your camera from the third pop-up menu **(3.47)**.

3.47 A third condition specifies a camera model.

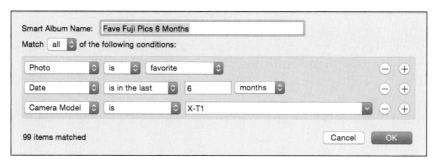

8. Click OK to create the smart album and view its contents.

When you go to the Albums view, the smart album appears with a gear icon next to the name to indicate what a smartypants it is **(3.48)**.

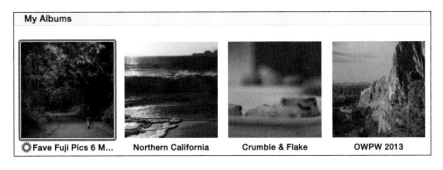

3.48 Smart albums intermingle with regular albums.

▶ **NOTE** If your library was migrated from iPhoto or Aperture, you could replace the Favorite condition and account for the former star ratings, which were converted to keywords (see Chapter 2), such as "Keyword is 4 Star." Unfortunately, this is where the lack of a rating system gets in the way: You can't specify "images rated 4 stars or higher" as was possible in iPhoto and Aperture, and the conditions in the Photos application aren't granular enough to specify "Keyword is 4 Star or 5 Star." It's a new Favorites world, and we're along for the ride.

Identify Faces

I've written much in this chapter about various ways to organize your photos, such as adding keywords and marking favorites. In those cases, you're doing work to make it easier for the application to locate images (which we'll put to use soon, I promise). How about we let the computer shoulder some of the work, eh?

The Faces feature in Photos for OS X picks out people's faces in your photos—not just which images include shapes and colors that are vaguely face-like, but which faces belong to which people. It does require that you give the feature a nudge by identifying the folks you want, which isn't difficult or even time consuming.

To access the Faces feature, go to the Albums view or show the sidebar. Faces appears as one of the application's smart albums, but it's a little more tricky than that. Double-click the Faces album to get started.

Add new faces to the library

The Photos application has no trouble figuring out when a person's face appears in a photo, but first you must add a face to the library:

1. From the row of found faces in the Faces album, double-click one.

2. Type the person's name in the field provided (3.49). The app cross-references your Contacts list and brings up suggestions; choose one and click Continue.

3.49 Identify a
new face.

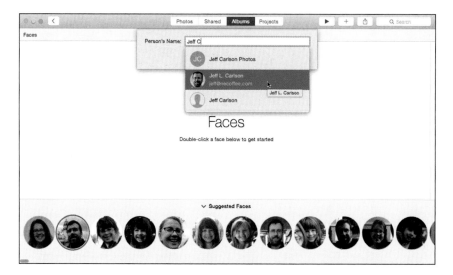

3. On the next screen, verify that the same person appears in the photos presented (3.50). If a match is incorrect, click the image to deselect it. Click Add and Continue to review more; or, click Finish Later to pick it up some other time.

▶ **TIP** Position the mouse pointer within the circle identifying a person to zoom in for a better look at the face.

4. Continue identifying faces until Photos reaches the end of its queries. The app adds many photos automatically. Click Done. The person appears in the main portion of the Faces album.

▶ **TIP** Once you've added a person, you can also drag other instances of them from the Suggested Faces row to the person's icon in the Faces area.

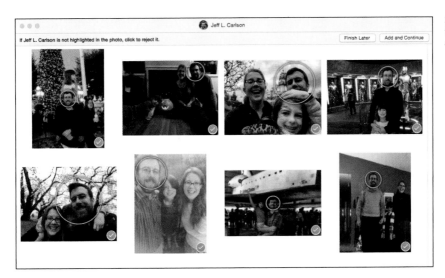

3.50 Confirm that the faces identified are accurate.

If you chose to finish verifying faces later, you can start again by double-clicking a suggested face that matches a person you've identified; Photos returns to the confirmation sequence. Or, double-click a person in the Faces screen and look for an Add button at the upper-right corner with the text "*[Name]* may be in additional photos."

When you run across a face in the Suggested Faces row that you don't want to identify—someone you don't know in the background of a photo, for example, or something that isn't a face—select it and press Delete, or right-click and choose "Ignore this face" from the contextual menu (3.51).

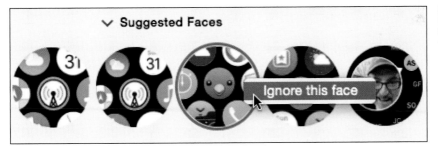

3.51 Not that Ollie isn't photogenic, but it's not the type of face I'm looking for.

▶ **TIP** Don't like the photo that the application chose for the Faces icon? Double-click the icon to reveal all photos marked with that person, and locate a better alternative. Right-click to bring up the contextual menu, and choose Make Key Photo.

Identify faces in photos

Another way to pinpoint people in pictures is to identify them as you're looking at each photo. Choose View > Show Face Names to reveal tags in images where Photos has located a face. If it's a face you've already defined in the Faces album, that name will be listed.

If not, the person is Unnamed; click the badge and type the person's name, matching it with your contacts if applicable (3.52).

3.52 As you browse your library, name the people that Photos has identified.

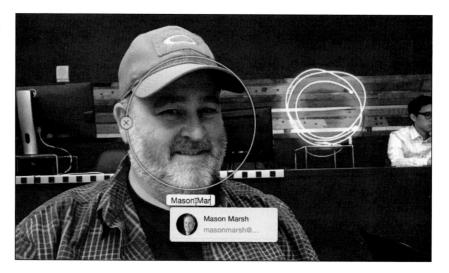

Remove faces from the library

If you don't want to track someone in the Faces album—perhaps they appear in only a few shots—right-click or Control-click their icon in the Faces view and choose Remove Person from Faces. Doing so won't erase any photos from your library, just the internal tag that identifies the person on those shots. Click Delete in the confirmation dialog.

Browse photos using faces

After you've set up a few faces, double-clicking one leads to a listing of every photo in which that person appears. Initially you see just the person's

face in a circular thumbnail; click the Photos button at the top of the window to view the actual photos (3.53).

3.53 The Faces view and the Photos view of the same images

What if you accidentally approved a face that isn't correct, or the Photos application guessed incorrectly? When reviewing a person in the Faces album, right-click the thumbnail or photo that doesn't belong and choose "This is not *[Name]*" (Faces view) or "*[Name]* isn't in this photo" (Photos view) (3.54).

3.54 This is not my beautiful house. This is not my beautiful wife!

Search for (and Find) Photos

Most people probably search through their photo libraries by scrolling, going back in time to the point at which they think a photo was taken. That's a fine method that becomes more difficult the more photos you add to the library. Most of the steps we've taken in this chapter, from assigning keywords to identifying faces, have been in the service of doing a better job of finding photos when you need to. If you've ever spent an hour looking for one image, you know what I'm talking about.

Photos for OS X and Photos for iOS each include a Search field that's designed to locate images fast.

Search in Photos for OS X

To locate photos on the Mac, do the following:

1. Click the Search field and start typing a search term. That could be a keyword, location, name, camera model—pretty much anything.

2. The application starts building a list of results as you type (3.55). Select one to view the results.

3.55 The Search field finds several types of criteria. In this case it knows that I'm looking for photos taken in California during the month of May; I added San Francisco at the last minute to narrow the search without starting over.

The photos that appear are only those that match the search criteria (3.56). If you want to return to the full library, you can either click the Cancel

button or, to view a photo in the context of other images captured with it, click the Show Moment button.

3.56 Viewing the search results

Search in Photos for iOS

The search feature is similar on the iPhone and iPad, with a couple of wrinkles. Although there's no feature for adding keywords or identifying faces on iOS, the Photos app recognizes them and uses them when searching the library if your library is synced via iCloud. There are also shortcuts to photos captured near your current location, to your favorites, to photos taken at home (the address in your Contacts list that you identify as your home), and to others.

1. In the Photos app, tap the Search button (the magnifying glass icon) to reveal the Search field **(3.57)**.

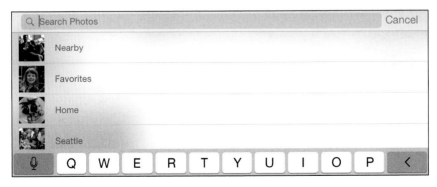

3.57 Searching on an iPhone

2. Tap one of the shortcut searches, or start typing a search term (3.58).

3. Tap one of the results to view the photos (3.59).

3.58 A text search brings up keywords I applied in Photos for OS X (this is for a library that is synchronized using iCloud Photo Library).

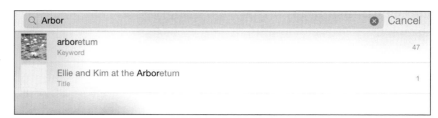

3.59 The search results

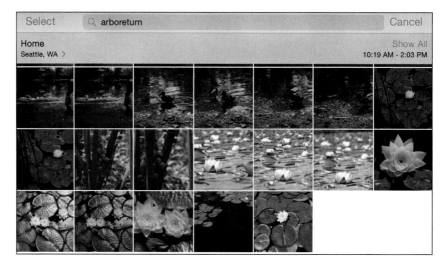

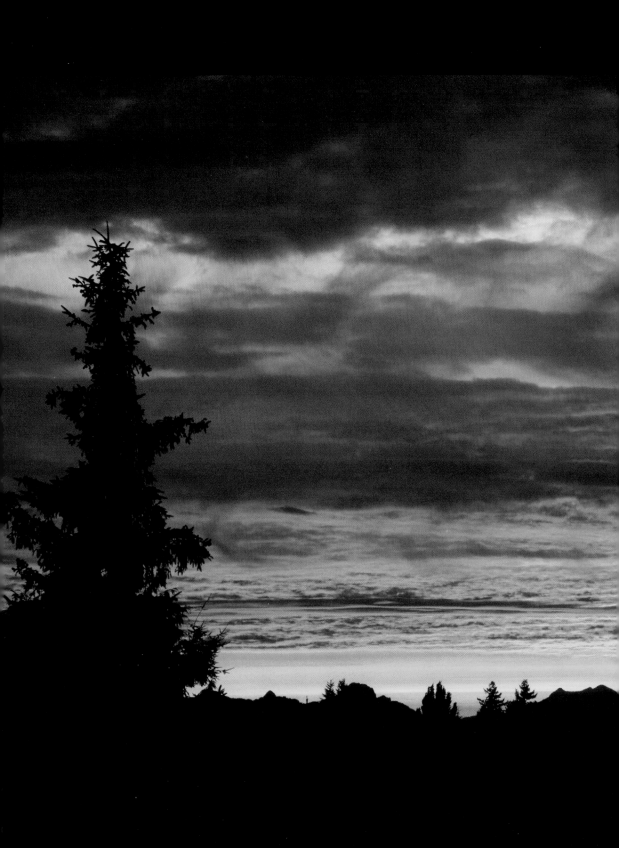

CHAPTER 4

iCloud Photo Library

Over the years, iPhoto got to be pretty creaky and slow, which by itself is reason enough to overhaul the whole thing. But Apple's work to replace iPhoto with the Photos for OS X app was, I believe, less about modernizing iPhoto's code and more about making cloud synchronization work.

Here's the problem: We have thousands of photos, and we also have mobile devices that can't possibly store them all. Even though we rarely, if ever, need entire libraries on our iPhones, we also don't like monkeying about with manual syncing.

iCloud Photo Library is Apple's grand attempt at making all your photos and videos available on any device, at any time. It's easy to set up, and has genuinely changed how I work with my library and also changed my expectations for how photos should work on mobile devices.

iCloud Photo Library Basics

Before I get into how to use iCloud Photo Library, let's cover just what it is, what's involved, and other important things to know before you decide to set it up.

iCloud Photo Library is not required

When Photos for OS X was first announced, Apple emphasized iCloud Photo Library to the extent that many people assumed (and still assume) it's required to use the new software. *The feature is entirely optional.* In fact, in some cases you may not be able to use it.

If you own a Mac and have no interest in viewing photos on mobile devices, you can ignore this feature. If you do own an iPhone or iPad and want the photos you capture with those to transfer easily to your Mac, you can enable My Photo Stream (see the next item).

Telling Apple's cloud photo services apart

Apple offers three separate, but sometimes linked, cloud photo services, which were introduced at separate times.

- **iCloud Photo Library:** The most recent service makes your entire photo library available via iCloud to iOS devices and the Web (when you log in with your Apple ID).

- **iCloud Photo Sharing:** This service lets you create shared albums to which other people subscribe. When new photos are added to an album, everyone receives the images. For example, I created a shared album of recent photos of my daughter so family members near and far get to stay current with what she's up to. Subscribers can comment and like the photos, and in some cases contribute their own photos for everyone else to see.

- **My Photo Stream:** Apple's first foray into cloud-based photo sharing, this service automatically transfers photos you capture using an iOS device to the cloud. Within a few seconds, the photos appear on other iOS devices and in Photos for OS X (if enabled). You can do the same thing with iCloud Photo Library, but there are restrictions you need to be aware of (see "My Photo Stream," later in this chapter).

How iCloud Photo Library works

The key component is iCloud—it's the central hub from which photos and videos are propagated to your devices (4.1).

The images in Photos for OS X and in Photos for iOS on your devices are uploaded to the iCloud servers and stored as your photo library. From there, images that appeared in one location but not the others, such as photos you capture using the iPhone's camera, are copied to the other destinations.

The result is the same library—including the same albums—on every device.

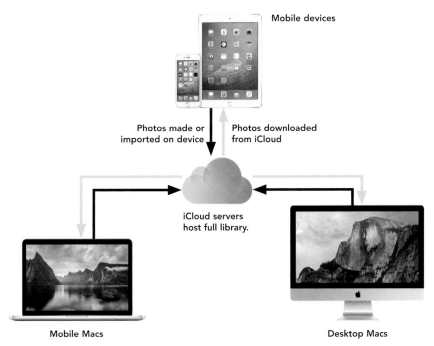

Mobile devices

4.1 iCloud Photo Library is the hub for all photos created in or imported into the Photos apps on your devices.

Photos made or imported on device

Photos downloaded from iCloud

iCloud servers host full library.

Mobile Macs

Desktop Macs

Here we run into a conundrum: Not all devices have the same amount of storage. If your iPhone is a 16 GB model, but your photo library is larger than that, how does your entire library show up on the iPhone?

The Photos apps store compressed, low-resolution versions of your photos on the mobile devices—and optionally on the Macs—so you can access your entire library. When you want to view a photo, a higher-resolution version is downloaded as needed.

> ▶ **TIP** Depending on the amount of free space on your devices and Macs, you can opt to store originals instead of low-resolution versions. See "Set Up iCloud Photo Library," just ahead.

> ▶ **NOTE** What about raw images? Your raw originals (and Raw+JPEG pairs) are uploaded to iCloud and stored there. iCloud creates low-resolution JPEG versions for storage on devices. Opening one on the Mac loads the original for editing. Opening one on an iOS device loads a high-resolution JPEG for editing, since iOS does not support working with raw formats; any edits you make on iOS, however, apply to the raw version on the Mac when they're synchronized.

iCloud storage requirements

Depending on the size of your photo library, you'll need to pay Apple for iCloud storage. A free iCloud account includes 5 GB of storage, but that amount is used by all iCloud services, such as iCloud Drive and iOS device backups (if you back up to iCloud). If your photo library is larger than that, you need to pony up for a paid service tier:

- 20 GB for $0.99 a month
- 200 GB for $3.99 a month
- 500 GB for $9.99 a month
- 1 TB for $19.99 a month

That 1 TB plan is the largest option available. If your library is larger than 1 TB, you can't use iCloud Photo Library.

Also, if you bump up against the limit of your current plan (say, you import a bunch of photos that push you past 20 GB), the Photos apps will stop updating until you either delete photos to make room or move up to another paid tier.

To see how large your library is, do this:

1. In Photos for OS X, go to the Photos tab and make sure no images are selected.
2. Choose Window > Info and look at the size listed at the top (4.2).

4.2 See how much storage your Photos library occupies.

> ▶ **NOTE** If you're not subscribed to a higher tier and your library exceeds 5 GB, the Photos app won't even let you turn on iCloud Photo Library in the first place.

> ▶ **NOTE** Yes, Apple's prices for cloud storage are higher than competing services like Dropbox, Google, or Flickr. I hope Apple reconsiders their pricing in light of these other services. For now, you can justify the price of using iCloud Photo Library as being part of Apple's ecosystem and the way the Photos apps work on all Apple products. To stay on topic, I'll be covering just Apple's service in this book, not the others.

Library must be the System Photo Library

If you have multiple Photos library files (such as if you converted old libraries or created separate ones; see Chapter 3), only one of them can be used as the iCloud Photo Library. To set this up, open the Photos preferences, click the General button, and then click Use as System Photo Library. If the option is grayed out, it means that library is already set as the System Photo Library (4.3).

4.3 Designate your System Photo Library.

Set Up iCloud Photo Library

In true Apple fashion, turning on iCloud Photo Library is almost a one-click operation. Here's how to enable it in Photos for OS X and Photos for iOS, plus the settings you need to be aware of to make it work well.

Photos for OS X

To get iCloud Photo Library working on your Mac, do the following:

1. First, you need to be signed in to iCloud. If you're not already, open System Preferences, click the iCloud icon, and enter your Apple ID and password. You can also reach the same point from the preferences window in the Photos application, under iCloud.

2. In Photos, go to the iCloud preferences window and click the iCloud Photo Library checkbox (4.4). Once it's enabled, Photos begins uploading the contents of your library to iCloud.

4.4 Enable iCloud Photo Library.

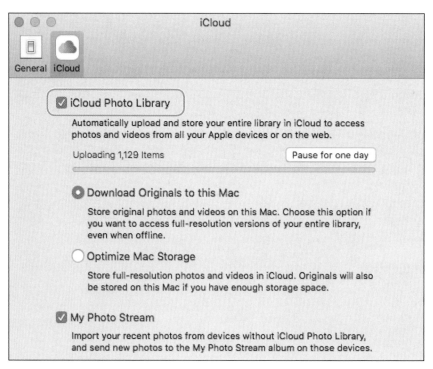

▶ **TIP** Behind-the-scenes nerdery here: All the screenshots of iOS devices in this book were made by taking advantage of iCloud Photo Library's synchronization. My iPhone, iPad, and MacBook Pro all share the same library, so when I created a screenshot on my iPhone or iPad (by pressing the Home button and Sleep/Wake button simultaneously), the image was immediately synced to iCloud and appeared in Photos for OS X on my Mac within a couple of minutes.

Merge Libraries via iCloud Photo Library

Although this is an unconventional approach, it's possible to use iCloud Photo Library to merge multiple Photos libraries. I still advocate merging iPhoto libraries before converting them to Photos (see Chapter 2), but imagine this: You create a new empty Photos library on your Mac for an event, like a wedding or a vacation. After it's over, you want to bring those images into your main Photos library that's set up with iCloud Photo Library. The trick is to designate the new library as your system library, allow the photos to upload to iCloud, then switch back to your main library, like so:

1. Launch Photos while holding the Option key, and choose the new library.

2. Open the Photos preferences, and click the Use as System Photo Library button.

3. Click the iCloud button, and enable iCloud Photo Library.

After a while, the new library's contents are mingled with the set at iCloud. When it's done, open your main library, set it as the System Photo Library and enable iCloud Photo Library again, and the photos from the other library download.

iCloud Photo Library on the Web

Having your photo library available no matter where you are isn't limited to just the devices you own. As long as you can access the Web, you can view your photo library.

1. In a Web browser, go to www.icloud.com.

2. Sign in using your Apple ID and password.

3. On the Home screen that appears, click the Photos button. You can do most everything in your library that you can in the Photos

application aside from editing the images, including sharing and marking favorites (4.8). Albums remain intact, but smart albums show up empty, since their contents aren't auto-generated via the Web interface.

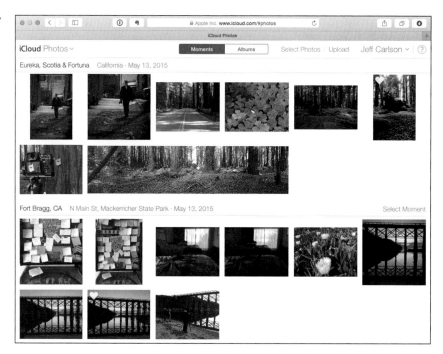

4.8 Your photo library at iCloud.com

My Photo Stream

With the rollout of Photos for OS X and iCloud Photo Library, the My Photo Stream feature has gotten pushed out of the spotlight. If you've decided that iCloud Photo Library isn't a good fit for you—or it was decided for you, if your library is too large, your network connection too slow, or your library includes referenced photos—My Photo Stream is still helpful for automatically transferring photos between devices. It also works for syncing photos to devices that share the same iCloud account but don't have iCloud Photo Library turned on.

Set up My Photo Stream

Here's the easy part. In Photos for OS X, open preferences, click the iCloud button, and then turn on My Photo Stream.

On an iOS device, go to Settings > iCloud > Photos and turn on My Photo Stream (4.9). After you do, a new My Photo Stream album shows up in the Albums view (4.10).

▶ **TIP** If iCloud Photo Library is enabled, you won't see a My Photo Stream album, because all synced photos and videos go to the All Photos album.

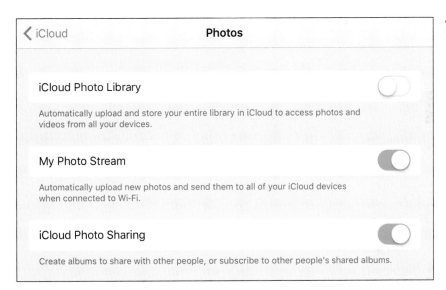

4.9 Enabling My Photo Stream

4.10 My Photo Stream appears as an album.

My Photo Stream limits

Unlike iCloud Photo Library, the My Photo Stream service does not count against your iCloud storage allotment—in fact, you can stick with the free 5 GB iCloud account and still use My Photo Stream. However, there are limitations to how much you can store. As its name suggests, it's a stream of data that rushes by, not a pool where all your photos are stored indefinitely. So here's the breakdown:

- Photos in My Photo Stream are stored at iCloud for 30 days. Older photos are removed from the stream after 30 days.

- On iOS devices, the last 1000 items are saved in the My Photo Stream album.

- If you'd like to keep a photo on an iOS device before it's deleted, move it to the Camera Roll by selecting the photo, tapping the Share button, and choosing Save Image.

- Only photos are supported in My Photo Stream, not videos.

▶ **NOTE** For more information about My Photo Stream, see Apple's support document at support.apple.com/en-us/HT201317.

Edit Your Photos

Photo editing encompasses a broad spectrum. You may only need to crop a photo to focus on someone in the scene, or you may want to radically change the tone and color of the shot to match a mood or compensate for less than ideal shooting conditions. The Photos apps for OS X and iOS offer surprisingly sophisticated controls for correcting images.

I say "surprisingly" because Apple could have made the editing tools extremely basic to appeal to the widest array of customers. They didn't. In fact, the tools in Photos for OS X are some of the best I've seen in terms of applying sophisticated adjustments using a simple interface.

This chapter goes into detail about the Photos for OS X editing capabilities and also covers those in Photos for iOS. There's a lot of overlap between the two, as well as features that are unique to each platform.

Edit Images in Photos for OS X

When you're viewing a single photo, click the Edit button at the upper-right corner—but wait, there's a better way: In single view mode or with a photo selected in the Moments view, press the Return key to jump to the editing view. The application's background turns black and the editing tools appear to the right of the image (5.1).

> ▶ **NOTE** If Photos is storing optimized versions of images, the original is downloaded before it can be edited.

5.1 The editing view

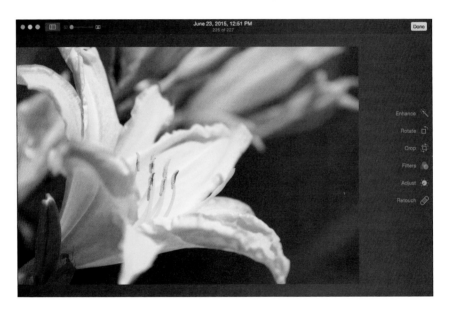

Working in the editing view

I'll jump into the individual tools as we proceed, but first we need to cover some important features of editing photos, such as non-destructive editing, making duplicates, and accessing additional adjustments that aren't immediately apparent.

> ▶ **TIP** At any point while you're editing a photo, press and hold the M key to compare the edits with the original version of the image.

Access editing tools

The options at the right are a mix of tools and categories: Clicking Rotate, for example, turns the photo 90 degrees, and clicking Adjust brings up controls for editing light, color, and black and white tones (5.2).

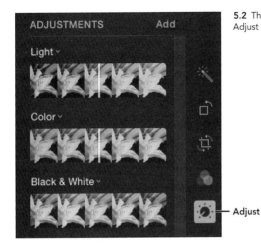

5.2 The initial Adjust controls

Adjust

▶ **TIP** You can also press keys to quickly access the tools: **C** for Crop, **F** for Filters, **A** for Adjust, **R** for Retouch, and **E** for Red-eye.

In the Adjust tools, what you initially see are the "easy" controls. For finer-grained control over each adjustment type, click the arrow to the right of the tool name (which appears when you move the mouse pointer near it); additional sliders appear for specific edits (5.3).

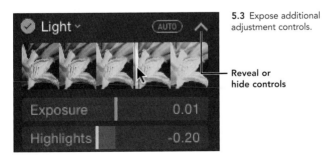

5.3 Expose additional adjustment controls.

Reveal or hide controls

▶ **NOTE** All of the adjustments in the editing view apply to the entire image, with one exception: the Retouch tool. There's no way to make just the sky portion of a photo darker, for example.

Full screen mode

Working in the editing view is a good opportunity to take the Photos app full screen to see more of what you're working on. Click the green Zoom control at the top-left corner of the window, choose View > Enter Full Screen, or press Command-Control-F.

▶ **TIP** Full Screen mode moves the Photos app to its own screen, a feature in OS X that creates virtual environments that work side by side. You can switch between full-screen apps by pressing Control and the left or right arrow key or, if you have a trackpad, swiping left or right with three fingers. If you want to use your entire screen but not go into Full Screen mode, hold Option and click the Zoom control: the application's window resizes to fill the screen without switching to a new space.

In order to present as much of the image as possible, the toolbar is hidden in Full Screen mode. Move the mouse pointer to the top of the screen to reveal it. Or, choose View > Always Show Toolbar in Full Screen.

To exit Full Screen mode, click the Zoom control, choose View > Exit Full Screen, or press the Esc key.

Add adjustments

One of the editing environment's best features is almost invisible. When you click the Adjust button to reveal the Adjustments controls, Photos shows Light, Color, and Black & White. But the application is capable of several more tools. Click the Add button to reveal a pop-up menu containing more options and choose one (5.4).

For example, I recommend turning on the histogram, which details the levels of light and dark pixels in each color channel (red, green, and blue). It's a good reference to make sure your photo is balanced well. Unlike the other options in the Add pop-up menu, Histogram doesn't offer any controls for manipulating the image, but it's helpful regardless.

If you find yourself turning to other tools often (such as White Balance), make sure the ones you want are visible and then choose Save as Default from the pop-up menu. That set appears whenever you use the Adjust tools.

▶ **TIP** The Photos for iOS app doesn't include all of the same editing controls as Photos for OS X, which can lead to some odd behavior when editing on both platforms. See the sidebar "How Edits Transfer Between OS X and iOS," later in this chapter.

 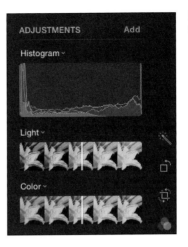

5.4 Add controls such as the histogram.

Revert to original and undo adjustments

Just as important as knowing how to edit a photo is being able to back out of those changes if necessary. Edits made to photos in the Photos app are *non-destructive*, which means the adjustments aren't permanently burned into the image file. You can always discard the edits and return to the image as it was imported into your library by clicking the Revert to Original button that appears (5.5).

5.5 Revert to discard any edits.

However, reverting is the nuclear option: it removes *all* adjustments from a photo. When you make an adjustment, a blue checkbox appears next to the name. To hide the adjustment without removing its settings, click that checkbox to turn it off (5.6). To reset the adjustment to its unapplied state, click the adjustment name and choose Reset.

Hide adjustment

5.6 Hide or reset an adjustment.

Experiment on duplicates

Since edits are non-destructive, feel free to make any types of adjustments you like. In fact, you may want to create several versions of a photo—one color, one black and white, one cropped a different way. In that case, duplicate the image: With it selected or viewed on its own, choose Image > Duplicate Photo, press Command-D, or choose Duplicate Photo from the contextual menu. (You can also select multiple files in the Moments view and duplicate them at once.)

A new image appears with "Version 2" appended to the title. When you edit that new version, either build upon the edits you made on the first one or click Revert to Original and start over. Making duplicates doesn't create new image files on your hard disk—each revision is based on the original file (5.7).

5.7 Duplicates made from the same original image

Summer Sun

Summer Sun – Version 2

Summer Sun – Version 3

Work with Raw+JPEG images

Photos for OS X works with JPEG images created by most cameras (the format used by the iPhone and iPad) as well as raw formats used by many cameras. JPEG images are optimized and compressed within the camera; raw files include all the data recorded by the camera's sensor, and therefore contain more image information than Photos can work with.

▶ **NOTE** For whatever reason, camera manufacturers create new versions of their raw formats with the release of every camera. When a new model comes out, there may be a delay while software makers like Apple and Adobe add support for that format. Apple adds to its list of supported raw file formats on a regular basis as updates to Mac OS X.

Most cameras that support shooting in raw also include a Raw+JPEG mode, which makes two image files for each capture: the raw file and a

separate JPEG file. When imported into Photos for OS X (or Photos for iOS), the Raw+JPEG pair are treated as a single image. On the Mac, a badge in the lower-left corner tells you which version you're seeing (5.8).

5.8 Both images are Raw+JPEG, but the one on the right is working with the raw versions.

> ▶ **NOTE** The format badge appears only for Raw+JPEG photos. Individual JPEG and raw files don't show a badge at all. Look in the Info window for the filename to check the format. If it's JPEG or JPG, it's a JPEG file; raw files use names such as NEF (Nikon), CR2 (Canon), or RAF (Fuji).

The JPEG version is the default, but you can edit the raw version instead. That can be done only when the editing view is active: Open a photo in the editing view, and choose Image > Use RAW as Original. Or, right-click or Control-click the image in the editing view and choose Use RAW as Original from the contextual menu (5.9).

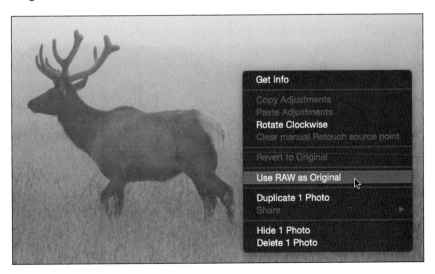

5.9 Change the photo's source image in the editing view.

The appearance of the image will likely change (as you can see in the previous figure), because Photos for OS X processes the file using the raw profile for that camera's raw format. That happens because the JPEG portion of the Raw+JPEG pair represents how the camera did its own processing of the image data.

To switch back to the JPEG version, go to the same menu and choose Use JPEG as Original.

▶ **NOTE** Unfortunately, there's no way to set the raw version as the editable choice for multiple Raw+JPEG photos at once; you must do it each image at a time. Similarly, there's no direct way to import only the raw portions of the Raw+JPEG pairs; you'd have to copy the files from the memory card to your hard disk, delete the JPEGs, and then import the raw files into Photos.

Reprocessing Raw Files

The Image menu includes another item related to raw photos: Reprocess RAW.

As image technology advances, developers improve the algorithms that turn the raw image data into usable images. For example, today's software typically does a better job of revealing details in dark areas of a photo than the early raw processors could do. If you come across an old raw format photo that you want to edit, choose Image > Reprocess RAW in the editing view; the Photos app analyzes the data and presents an updated image.

This isn't a feature that comes up often, but it's good to have when you revisit old photos, or in the future when we may want to reprocess today's shots.

Automatically enhance the photo

I freely admit that some readers probably just glossed over the previous few pages—and that's fine (it's there for when you want to refer back to it). Editing photos can prompt a brain-lock: *I just want to make my photo better. I don't want to become an image-processing expert!* Many aspects of the Photos application are designed specifically for this desire. At the top of the list is the Enhance tool.

Enhance is literally a one-click "make better" tool. Open a photo in the editing view and click the Enhance button. Photos evaluates the image and makes whatever corrections it deems appropriate.

If you don't like the result, Choose Edit > Undo (or press Command-Z), or click the Revert to Original button.

▶ **TIP** Here's a not-so-secret secret: I use the Enhance tool all the time. It's usually not the last tool I use, but it's almost always a good first step to figuring out what other adjustments need to be made.

Crop, straighten, and rotate

Two of the most common photo adjustments deal not with color or lighting but with composition. Often the camera is angled just a little (or a lot) off-axis, leading to sloping horizons. Or sometimes the image includes distractions around the edges that you want to remove.

The Crop tool deals with both situations. In the editing view, click the Crop button and do any of the following:

- Click the Auto button to let Photos attempt to straighten the image for you.

- Drag the wheel control to the right of the image to straighten the image manually (5.10). Photos crops the edges automatically so the entire photo fills the frame.

5.10 Straighten a skewed horizon.

- To crop the photo, drag an edge or the corner of the bounding box. Remember, the edits are non-destructive, so you can change the crop later if you want.

- Normally, the crop control is freeform, meaning you can change the border to any size you'd like. If you'd prefer to use a specific aspect ratio, such as square or a common photo print size, click the Aspect button and choose from the options that appear (5.11). When you make any selection other than Freeform, the bounding box locks to that aspect ratio as you drag an edge or corner.

- To reposition the photo within the frame, drag the middle of the image.

- Click the Flip button to flip the photo horizontally; Option-click it to flip vertically. You can also choose Flip Horizontal or Flip Vertical from the Image menu.

5.11 Choose an aspect ratio and drag an edge or corner to resize the photo's borders.

▶ **TIP** If you're planning on making prints of a certain size, you can crop the image here to that aspect ratio. However, you don't need to. When ordering prints from within Photos, you have the option of repositioning the image within a print size's constraints during the ordering process. I'd rather make the photo the best it can be when editing it in general, and then deal with print sizes at the printing stage.

- **Shadows:** Increasing the Shadows value reveals detail in dark areas.

- **Brightness:** This control affects the overall brightness of the image. Exposure and Brightness appear to be overlapping controls, but they do work differently; Exposure affects all tones in the image, whereas Brightness affects the general lightness of the shot (5.17).

Exposure: +50

5.17 Comparing Exposure and Brightness, starting from the photo's original unedited values: Brightness retains more detail in the sky and some color from the sun on the horizon.

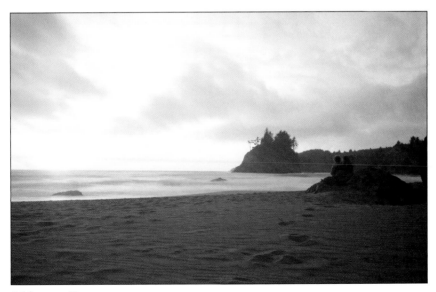

Brightness: +50

- **Contrast:** This control affects the difference between light and dark values.

- **Black Point:** The black point of an image is the level at which dark pixels turn to pure black. By changing the black point, you can make dark areas darker, without resorting to adjusting the exposure for the entire photo.

▶ **NOTE** As you edit a photo, you can repeatedly choose Edit > Undo to undo previous adjustments. However, after you click Done to stop editing, that undo history is discarded. The next time you open the image in the editing view, the undo history is reset.

Histogram

As you make adjustments to an image, the histogram changes to reflect the light and dark values of the scene. (If you don't see the histogram, choose Histogram from the Add pop-up menu. I recommend leaving it on all the time as reference: make sure it's visible and then choose Set Default from the bottom of the Add pop-up menu.)

The left side of the histogram represents black pixels, and the right side represents white pixels. In the histogram in Photos for OS X, you also see the brightness values of each color channel (red, green, and blue). A photo is generally considered balanced when the histogram looks like a mountain: low on each edge and rising in a bump in the middle (the midtones).

A quick look at the histogram can tell you a lot about what's going on—and what can be improved—in the image. For example, let's take a photo that is underexposed (5.18). The values are bunched up against the left side of the histogram; there are a lot of black and dark tones, and little or no white or bright tones.

5.18 The histogram for an underexposed photo

Levels

For much more control over the photo's light, click the Add pop-up menu and choose Levels. The histogram in the Levels control represents the photo's original values, and doesn't change. Instead, the handles in the control affect the photo's values. The histogram at the top of the list reflects the adjustments (and also remains visible, even if you scroll down).

Move the handles to edit the photo (5.19): In this case, I dragged the rightmost handle, which represents the image's white point (note the white dot on the handle). Any pixels on the spectrum to the right of the white point are turned to pure white, and everything else is shifted lighter.

The center handle adjusts the midtones, and the smaller in-between handles affect shadows and highlights.

The handles at the top allow even finer adjustments, based on the setting of the handles at the bottom: For example, drag the top shadows handle to affect the shadows in smaller increments. You can also hold Option and drag a handle to move the top and bottom handles in unison, keeping the relationship steady between the shadows and the fine-tuned shadows settings.

Original

Adjusted

5.19 Adjusting the white point using the Levels control

Black point | Midtones | White point

Shadows | Highlights

The Levels tool also affords a degree of specificity in working with the image's luminosity—its overall brightness—as well as working with the individual red, green, and blue color channels, which I detail in the next section.

Adjust color

The Color control, like its companion Light, can be adjusted using one central slider or broken down into three components: saturation, contrast, and cast (5.20); click the expansion arrow to reveal the individual controls:

- **Saturation:** This control adjusts the intensity of color in the image. Boosting saturation can give life to muted photos or give regular shots some kick, but it's also easy to overdo.

- **Contrast:** Color contrast involves increasing the separation between similar colors.

- **Cast:** If a photo has a color cast—in many cases, being too warm or cool—the Cast slider can help compensate.

5.20 The Color controls

White Balance

When a photo has a color cast, sometimes it takes more than the Color slider to adjust. The White Balance control examines an area that's neutral gray and modifies the color cast such that white areas appear actually white, and not other colors (hence the name). If photos are muted due to overcast skies, for example, the White Balance control can warm them up.

1. From the Add pop-up menu, choose White Balance.

2. Click the Auto button to attempt an automatic fix. Or, if you don't like the result, click the eyedropper button to select it and go to the next step.

3. Click a neutral gray area of the photo (5.21, on the next page). Don't worry if it's not strictly a neutral gray; the software will accommodate. You can also click other areas until the image looks right.

Expanding the tool reveals a Warmth slider that you can use for manually adjusting the warmth or coolness.

5.21 Click a neutral gray area to adjust white balance.

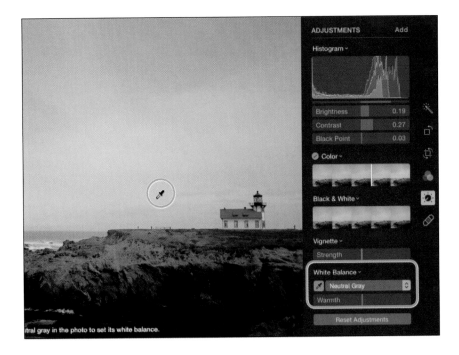

Neutral Gray is only one method of setting white balance. Click the pop-up menu to reveal two other options:

- **Skin Tone:** Use the eyedropper tool and click a person's skin to ensure that the skin tone remains natural and the rest of the scene's color adjusts accordingly.

- **Temperature/Tint:** Choose this option to set a specific color temperature or to balance a green or magenta tint in the image **(5.22)**.

5.22 Temperature and tint options

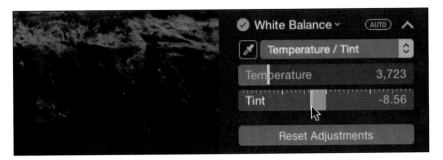

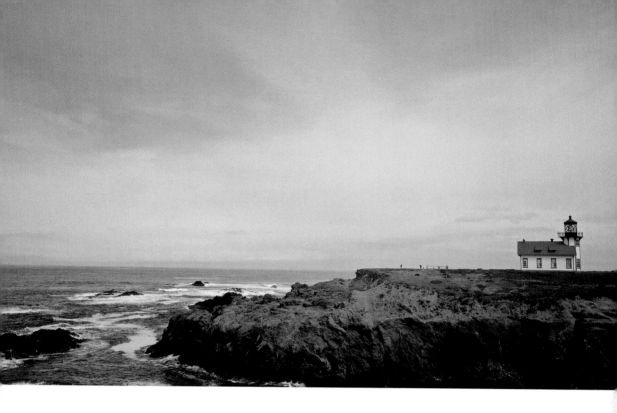

The Levels control

Coming back to the Levels control from a few pages ago, the color options for the tool enable you to adjust levels for the red, green, and blue channels individually. If your photo suffers from a green cast, you can reduce just the green tones. Or, for a more creative spin, you could accentuate a blue sky with a little blue push. Click the Levels tool's pop-up menu to choose the mode, and then adjust the values using the control points below the histogram (5.23).

5.23 Adjusting the blue channel only

Black and white

Converting a photo to black and white involves more than just removing its color (technically making it *grayscale*, but no one says they make grayscale photos). Behind the scenes, there's even a bit of color involved, as the software treats the colors in the image with differing hues of gray. In Photos, the Black & White slider presents a range of treatments for your shot, plus some additional controls to fine-tune a few aspects of the conversion.

In the Adjust tool, click anywhere on the Black & White slider to apply the effect (5.24). (This is also a good opportunity to click the Auto button and see what Photos comes up with.)

5.24 The Black & White controls

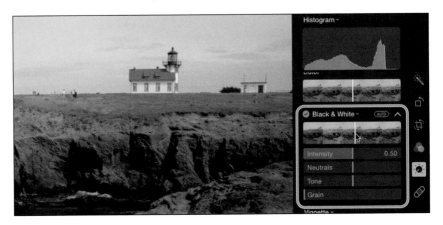

Now, drag the slider left and right—you'll notice some dark areas turn light and vice versa (5.25). Depending on the image, the effect may be subtle or dramatic.

5.25 Note the change in the tone of the lighthouse roof, which is red in the original photo, as the slider is moved.

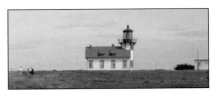

▶ **TIP** Don't forget that the Filters tool offers three black and white presets if you're looking for those particular looks. See "Filters," earlier in this chapter.

Unlike the sliders found under the Light and Color controls, which reflect the setting in the main slider, the ones that support the Black & White control are there to build upon the slider's setting:

- **Intensity:** This adjustment increases or decreases the black and white effect you've chosen. With a dark treatment, increasing Intensity makes it darker; with a light treatment, increasing Intensity makes it lighter.

- **Neutrals:** Drag this slider to darken or lighten the gray midtone areas.

- **Tone:** The Tone adjustment increases or decreases the contrast.

- **Grain:** This slider adds simulated grain that approximates the look of some black and white film stock.

Zoom to Check Details While Editing

As you're working on photos, make sure you zoom in to see how the edits are affecting the image at actual size. When you're seeing the entire image, even on a large screen, you may be missing details that aren't visible. Press the Z key to quickly zoom in to actual size where the cursor is located; you can also press Command-+ (plus) to zoom in incrementally, or Command-— (minus) to zoom out. (Those commands are also found in the View menu.)

For example, in the photo on the previous page, I decreased the Neutrals control to bring cloud detail back to the sky. However, that created a halo around the lighthouse—something I didn't see when viewing the full image. By zooming in, I could spot that issue and compensate by pushing the Neutrals slider toward the center until the halo disappeared **(5.26)**.

5.26 Pushing controls to extremes can sometimes cause haloing (the white border).

Detail adjustments

Four other adjustments in the editing view are designed for enhancing details: sharpening soft images, adding a vignette to the edges, and removing unwanted digital noise. Click the Add button to add the following adjustments; they're automatically enabled when you add them.

Sharpen

The Sharpen control helps you make fuzzy edges more crisp. It can't help with blurry shots that suffer from camera shake, but it's great when you want details to shine. Change the Intensity slider to adjust the effect's amount (5.27); too much can lead to aliasing or halos, so be conservative in its application.

5.27 Sharpen applied, before (top) and after (bottom): Note the appearance of the lettering.

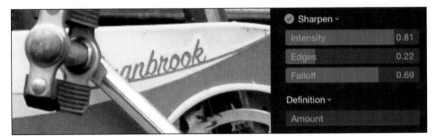

> ▶ **TIP** Sharpening is where the Zoom command is most helpful. Press the Z key to quickly zoom in and view the photo at actual size.

You can fine-tune the sharpening by expanding the control to reveal the following options:

- **Edges:** To sharpen an image, the software looks for edges within a photo. The Edges control tweaks how the adjustment defines an edge;

increase the value to be more aggressive about how the tool sees those borders.

- **Falloff:** This slider softens or accentuates the sharpening effect.

Definition

Definition at first sounds like another word for sharpening, but its implementation is broader. Allow me to quote Apple's Photos Help reference: Definition "add(s) contour and shape to photos as well as midtone definition and local contrast." Great! Wait, what?

It's ironic that the Definition tool's effects should be so vague. Think of it as a general "make better" tool that increases contrast and sharpens the image at the same time. The Definition tool has just one slider, Amount, which dictates how much definition is applied to the photo.

Vignette

A vignette is the darkening around the edges of a photo that camera manufacturers spend a lot of time and money trying to eradicate from their lenses. However, a vignette can also serve to add atmosphere to a photo or help draw the viewer's eyes to the center. Click the Auto button or anywhere on the Strength slider to apply the vignette (5.28).

Original

Vignette applied (Auto)

5.28 Vignette, before and after

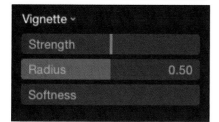

The Strength slider makes the vignette darker as you drag it to the right. Dragging it to the left, however, can be corrective: Apply a negative Strength setting to a photo with an existing vignette caused by a lens to undo the effect.

Clicking the expansion arrow reveals two more controls for changing the appearance of the vignette (5.29):

- **Radius:** The Radius slider determines how tight or wide the middle of the vignette appears. A higher value makes the visible area smaller; a lower value pushes the vignette to the outer edges.

- **Softness:** This slider changes whether the vignette is tight and dark or diffused.

In the figure below, I've pushed the Radius and Softness sliders further than I'd normally be comfortable with in order to show their effects.

5.29 Radius and Softness settings

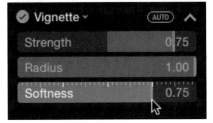

▶ **TIP** One cool thing about the Vignette tool is that it acts like an overlay on your photo. If you decide to crop the shot later, the vignette isn't also cropped; it's reapplied to the new size.

Noise Reduction

When you increase the ISO on your camera, you increase the image sensor's light sensitivity, allowing you to capture low-light photos that would be more difficult at low ISO settings. The tradeoff is noise—a graininess that presents itself especially in dark areas of a photo. The Noise Reduction control can help: Click the Amount slider (the tool's only option).

Noise Reduction has its own tradeoff: The control softens and merges noisy pixels so they don't stand out as much, which leads to an overall softening of the image. So as you experiment with the Amount slider, find an acceptable compromise between noise and smudge.

Retouch problem areas

The Retouch tool can repair blemishes caused by dust on the camera sensor or lens, or remove objects in the scene that are distracting. Click the Retouch tool in the editing view (or press R).

The tool fixes circular areas, so after you've identified a problem spot, drag the Size slider to make it just a bit bigger than the spot (5.30). Then simply click; the tool fixes the spot.

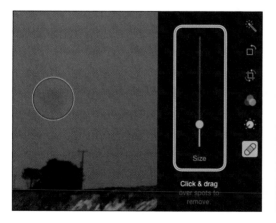

5.30 Either an evil spirit is hanging about or someone forgot to clean his lens.

Evil begone!

▶ **TIP** A faster way to resize the tool is to use the bracket keys ([and]). Or, if you're using a trackpad, hold Shift and swipe two fingers up or down. If you own an Apple Magic Mouse, hold Shift and drag one finger up or down.

In addition to making spot-fixes, you can drag the tool over an area to remove something that doesn't fit into a nice, clean circle (5.31).

5.31 Drag to erase an irregularly sized object.

> ▶ **TIP** While the mouse pointer is acting as the Retouch tool, you can move around the image by holding the spacebar, which turns the pointer into a hand icon, and dragging.

If you're familiar with other programs' retouching tools, there are usually two separate types: one that attempts to fix an area automatically when you click it, and a Clone tool that lets you sample a nearby source area to replicate over the spot you want to fix. The clone approach is good when you want to preserve textures; sometimes the spot-fix technique ends up with a soft blob that's almost as annoying as the thing you tried to remove.

Photos smartly combines the two into one tool. To clone an area, hold Option and click to define a source. Simply doing that tells the software that you'll be copying from the source area. Then, click the area you want to fix.

Although Retouch won't match the more sophisticated features found in something like Adobe Photoshop, you may be surprised at what it can do. Maybe you noticed in "Adjust light," earlier in the chapter, that the beach photo included a ghosted image of the woman watching the sunset, because she moved during a long exposure. (The couple was enjoying the moment; I wasn't going to be a jerk and ask them to hold still for my camera.) Here's how to correct it:

1. Press Z to zoom in on the area you want to edit. In this case, I'll press Command-+ to zoom in one more step, too.

2. Choose a size for the control.

3. Option-click the source area; the mouse pointer becomes a plus sign (+) to indicate you're adding a source (5.32). Fortunately, there's a block of trees in the background that will provide a good pattern.

5.32 Define a source for the clone.

4. Drag to paint the area to remove (5.33).

5.33 Select the area to replace with the cloned pixels.

Photos uses the texture of the source area to fill the area (5.34). You may need to re-clone the area to clean up the area, or to do the area in a couple of passes. If the cloning doesn't work, click the Reset button to undo the retouch work.

5.34 Partially cleaned up—a few more passes will minimize the ghosting.

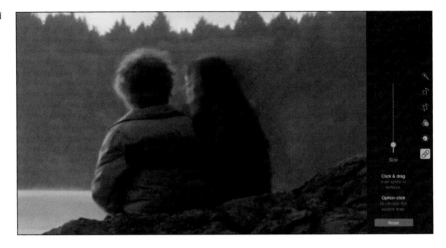

▶ **TIP** If you Option-click to define a source point but then change your mind, right-click or Control-click the image and choose "Clear manual Retouch source point" from the contextual menu to return to the Retouch tool's normal state.

In this example, I wasn't able to completely remove the ghost using Photos, but it's certainly minimized and looks more like subtle movement during a long exposure than like a noticeable shift (5.35).

5.35 The ghosting isn't as apparent after retouching.

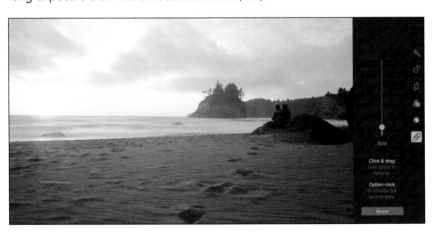

Fix red-eye

When you take a photo of someone straight-on and use a flash, often the person will appear in the image with glowing red eyes—the light bounces off the back of the eyeballs and is picked up by the camera sensor. We've all seen it, and we've probably all made photos that contain red-eye. And the Red-eye tool in Photos is here to fix it.

Normally, the Red-eye tool doesn't even appear in the editing view. My guess is that it comes up so infrequently that Apple's designers didn't want to clutter the interface with something you'd hardly use. That's why it was a surprise the first time I loaded a red-eye photo and saw the Red-eye tool automatically show up—Photos detects red-eye automatically. You can also opt to see the tool each time you open the editing view by choosing View > Always Show Red-eye Control. Or, press the E key. (I recommend that you also zoom in.)

To make the correction, click the Auto button to let Photos try first (it's pretty accurate). Or, use the Size slider to match the mouse pointer's circle to an eye's diameter, and then click the eye (5.36).

▶ **TIP** You don't need to be accurate about matching the size of the eyes. The tool is smart enough to pick out the affected areas.

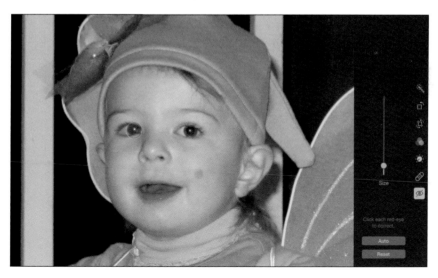

5.36 Fixing red-eye

Copy and paste adjustments

When you've edited a photo to your liking and then move on to another image shot near the same time, you don't want to have to start over from scratch. In the editing view, you can copy adjustments from the first image and paste them onto the other quickly. This feature works only in the editing view, and you can paste onto just one photo at a time, but it's a start:

1. After you've edited a photo, choose Image > Copy Adjustments or press Command-Shift-C. You can also right-click or Control-click to choose Copy Adjustments from the contextual menu (5.37).

5.37 Copy adjustments from an edited photo.

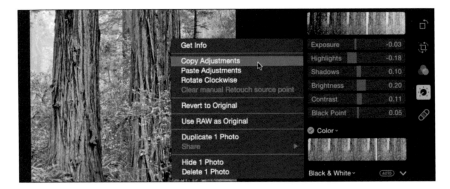

2. Open the photo to which you want to apply the same edits.

3. Choose Image > Paste Adjustments (Command-Shift-V), or choose Paste Adjustments from the contextual menu (5.38). The settings are applied to the image. You can paste the same adjustments on other photos until you copy another image's settings.

5.38 Adjustments are pasted (top) to make the treatment of the new photo match the previous one (bottom).

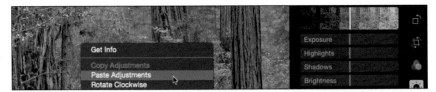

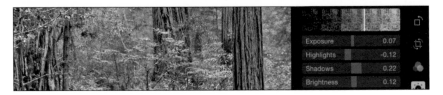

Edit Videos in Photos for OS X

The name of the app is Photos, but it can import and work with video clips, too. After all, the iPhone is one of the best video cameras on the market. It's not designed to assemble clips together or apply visual filters—that's what iMovie is for—but you can trim unwanted sections from the ends of clips, control which part of a Slo-Mo clip is in slow motion, save video frames as still photos, and more.

When you open a video clip and move the mouse pointer in the window, the video controls appear (5.39).

5.39 Video playback controls

Volume Time Elapsed Play/Pause Time Remaining Options

 Step Previous Step Next

Pressing the Step Previous and Step Next buttons take you through the video one frame at a time. If you'd prefer to review the video using fast-forward and fast-rewind buttons, click the Options button and choose Show Scanning Buttons. With those active, repeatedly clicking one accelerates the speed: 2x, 5x, 10x, 30x, and 60x.

▶ **TIP** When you close a video, the volume level and playback position aren't saved. So if you turned the volume down or stopped watching midway, the next time you view the video you'll be greeted with full volume at the beginning of the clip.

Trim a clip

When you want to share a video clip with someone, shorter is usually better—especially if there's footage at the beginning or end of the clip that's just waiting for the main action to happen. Photos for OS X can trim those sections:

1. Click the Options button in the playback controls and choose Trim. The controls change to a filmstrip surrounded by a yellow border.

2. Drag the handles at the start and end to define the footage you want to keep (5.40). Clicking the Play button plays only the selected portion so you can preview the new clip.

3. Click the Trim button to remove the footage outside the selection.

Remember that video edits are non-destructive, just like photo edits, so you can adjust the trim later by choosing Trim from the options pop-up menu. Or, choose Reset Trim from the menu to return the clip to its original length.

5.40 Trim a video clip.

> ▶ **TIP** What if you want to split a long clip into two separate clips? Select it, choose Image > Duplicate Video (Command-D), and then trim both clips.

After you've trimmed the clip, optionally choose which frame appears as the preview in Photos and when shared with others. In the playback

controls, move the playhead to the frame you want to use and then choose Set Poster Frame from the Options pop-up menu. That frame is used as the clip's thumbnail (5.41).

Thumbnail chosen by Photos

Poster frame set

5.41 Choose the poster frame for the thumbnail.

Edit Slo-Mo video

Slo-Mo video has an additional element: You can choose which portion of the clip plays in slow motion. The iPhone and iPad capture the entire clip at 240 frames per second (fps) or 120 fps, so you can make the whole thing slow or transition from regular speed to slow speed and back. (See Chapter 1 for more on shooting Slo-Mo video.)

Drag the handles of the slow motion controls to indicate where the effect begins and ends (5.42).

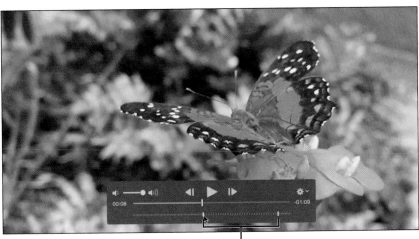

5.42 Slow motion controls

Slow motion section

Save video frames as stills

A video is made up of thousands of individual frames, any of which could be suitable as a still photo—especially in Slo-Mo videos, which exhibit less motion blur than regular-speed videos. To export a video frame as a still, do the following:

1. Using the playback controls, locate the frame you wish to export.

2. Click the Options button and choose Export Frame To Pictures (5.43).

3. The image file is *not* added to your photo library; instead, go to the Finder and locate the image in the Pictures folder within your Home folder (choose Go > Home). The filename is the timestamp of when you exported the image, such as "Frame-29-06-2015-11-09-51.tiff" (which translates to June 29, 2015 at 11:09:51 a.m.).

4. If you want to include the still image in your photo library, import it by dragging it to Photos or choosing File > Import and selecting the file.

5.43 Export a frame as a still photo.

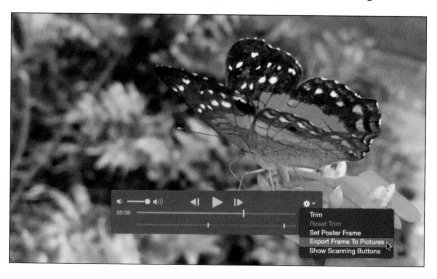

▶ **NOTE** Keep in mind that a frame extracted from a video has less resolution than a photo taken with a still camera, and will be constrained to the video aspect resolution.

Edit Images in Photos for iOS

If you have been following along so far (and didn't immediately jump to this section), you'll see that the editing tools in Photos for iOS are similar in many ways. The interface is different in places to accommodate smaller screens, but the general ideas behind the actions are the same. Of course, that's no accident: The iOS version of Photos was released much earlier than the OS X version.

Not all of the same tools are available on both platforms, though. The iOS version doesn't include the Retouch tool, for example, and several of the additional controls in the Adjust tool, such as Vignette, don't have a mobile counterpart. However, you'll have no trouble picking up the techniques.

Working in the editing view

In the Moments view, choose a photo and tap the Edit button. The place-ment of the editing tools depends on the device and its orientation: in portrait orientation, the tools appear at the bottom of the screen, and in landscape orientation, the tools appear at the side of the screen; on the iPhone, the Enhance and Red-eye tools are separate (5.44).

Portrait orientation

Landscape orientation

5.44 The editing view on an iPhone 6

With iCloud Photo Library enabled (see Chapter 4), your edits transfer between the Mac and mobile devices. Since adjustments are non-destructive, what gets passed through iCloud are the instructions to make the edits, not revamped versions of the images themselves. That makes edits update quickly and allows you to revert to the original photo at any time, on any device (but read the sidebar on the opposite page for an important limitation).

Work with Raw+JPEG images

Earlier in this chapter, I discussed how Photos for OS X treats Raw+JPEG image pairs when it comes to editing. On iOS, the situation is a little different.

You can import Raw+JPEG photos to an iPad using one of Apple's camera adapters, or you can import the files to an iPad or iPhone wirelessly using a variety of methods (some cameras include built-in Wi-Fi that can be controlled via apps; another option is to shoot using a Wi-Fi–enabled Eyefi card). The Photos app doesn't indicate which are Raw+JPEG, raw, or just JPEG—they're all just photos in the library.

However, iOS itself doesn't directly support raw files. Apple didn't build in the system-level translators that read raw files and construct images from the data. So, instead, when you import just a raw file, iOS uses the JPEG preview that the camera created (for you to review on its LCD). Often, that's a lower-resolution file than if you were shooting JPEG directly.

The advantage of shooting Raw+JPEG is that Photos for iOS displays and edits the high-resolution JPEG image that's bundled with the raw file. When you import and edit on an iPad, for example, you're working with a better image file.

If you've enabled iCloud Photo Library, the raw and JPEG files for each photo are stored at iCloud and delivered to your other devices—including Photos for OS X, which *can* work directly with the raw files. Any edits you make on iOS are transferred and apply to the raw version, as well, once you choose Image > Use RAW as Original.

What's good about this arrangement is that you don't need to worry much about what's going on in the background. The only complication arises when you're editing only raw files, only on iOS, where you're likely working with low-resolution versions.

How Edits Transfer Between OS X and iOS

Editing is *mostly* seamless between Photos for OS X and Photos for iOS, with one sticky exception you need to keep in mind.

When you edit using tools that are mirrored in both platforms, the adjustments carry over and remain editable. Making a change to the Light, Color, or Black & White controls of the Adjust tool show up the same on every device. For example, the values for the Light sliders are identical on the Mac and the iPhone (5.45).

Mac iPhone

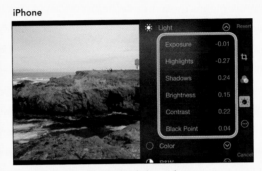

5.45 The adjustment values are identical when synced via iCloud Photo Library.

However, if you apply an adjustment that Photos for iOS does not support, such as Vignette, the effect shows up but all the sliders are reset to zero (5.46). Note that *the Light values themselves didn't change*—the image still looks the same except for the vignette. But the image on the iPhone is treated as if this were the starting point for editing. I hope this is simply a bug that will be fixed in a future update, or that the iOS version will soon support all the same edits found on the Mac, but for the time being it's something to be aware of as you edit.

Mac iPhone

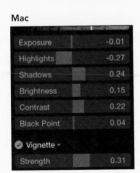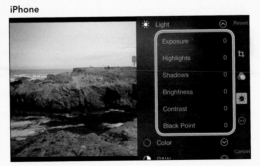

5.46 Adding a vignette resets the Light sliders to zero.

Crop, straighten, and rotate

To straighten or recompose a photo, open it in the editing view, tap the Crop button, and do any of the following:

- When you tap the Crop button, Photos automatically tries to straighten the image if there's a clear horizon line. If that doesn't happen, click the Auto button or drag the wheel control at right to manually straighten the shot (5.47).

- To recompose the photo by cropping it, drag the image borders. Click the Aspect button to select an aspect ratio and choose a size you want the border to be constrained to when you drag.

- If the photo was imported with the wrong orientation, tap the Rotate button to turn the photo 90 degrees counterclockwise. There's no clockwise option, so you may need to tap the button three times to turn an image right-side up.

5.47 Straightening the surf in iOS

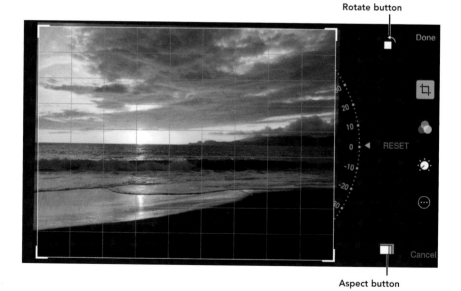

Rotate button

Aspect button

▶ **TIP** In the editing view in iOS, you may see an extra button that isn't found in Photos for OS X. The Extensions button appears if other photo-editing apps are installed on the same device and offer some of their features within the Photos app. See "Edit using other iOS apps' tools," later in this chapter.

Apply filters

When you want to apply a quick and easy look to your photo, apply a filter to it. In the editing view, tap the Filters button and choose one of the eight built-in presets (5.48).

► **TIP** To remove a filter and go back to the photo's previous state, you can scroll back to None—or simply tap the filter you just applied a second time.

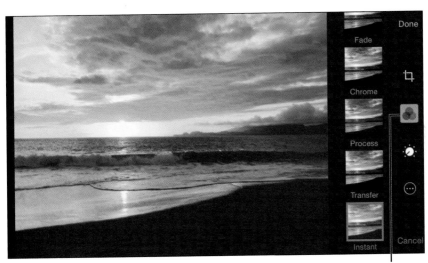

5.48 Applying a filter

Filters button

Automatically enhance the photo

Tap the Enhance button to let Photos perform its analysis and automatic correction to the image. The tool turns blue to indicate that it is active. Tap it again if you want to remove the automatic edit.

► **TIP** Hold three fingers on the screen to view the unedited "before" version of your photo, then release them to see your current edits.

► **TIP** When you adjust photos on your iOS device, make sure the screen brightness is set as high as it can go so you don't mistake a dim display for a lackluster photo. Swipe up from the bottom of the screen to open Control Center, and then drag the brightness setting all the way to the right.

Adjust light

Despite having less visual space to work in, the Adjust tools include both a main slider and individual controls for fine-tuning aspects of the tool's category. When you tap the Adjust button, the three main types of adjustments appear: Light, Color, and B&W (Black & White) (5.49).

5.49 The three Adjust tools on iOS

> ▶ **NOTE** The placement and appearance of the controls vary depending on whether you're using an iPhone or iPad. If you're using an iPad, don't be concerned if it looks different than what you see here; look for the same controls.

Tap the name of an adjustment to view its slider (5.50). Unlike on the Mac, under iOS the slider itself moves; the red line indicating the current setting stays in place in the middle of the screen. The gray dot indicates the photo's original setting.

Drag the slider to adjust the overall light levels of the scene.

5.50 The Light slider

To edit using the individual Light controls, do the following:

1. Tap the list button ().

2. Tap the specific control you want to use (5.51).

3. Drag the slider for that control until you like how it affects the photo.

4. To choose a different control, tap the list button again and choose the one you want.

5. When you're finished using the controls, tap Close.

Light controls listed

Click to reveal or hide the controls.

Editing the Contrast control

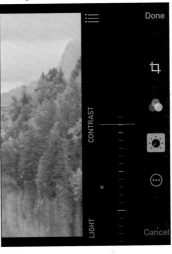

5.51 Accessing and using individual Light controls

The other Light controls function the same as they do in Photos for OS X. Here's a recap of what each slider does:

- **Exposure:** This control affects the overall light levels within the photo.

- **Highlights:** The brightest areas of a photo are controlled with this setting. Pulling the Highlights value back can often avoid blown-out areas when you increase exposure, shadows, or brightness.

- **Shadows:** Increasing the Shadows value reveals detail in dark areas.

- **Brightness:** This control affects the overall brightness of the image. Exposure and Brightness appear to be overlapping controls, but they do work differently; Exposure affects all tones in the image, whereas Brightness affects the general lightness of the shot.

- **Contrast:** This control affects the difference between light and dark values.

- **Black Point:** The black point of an image is the level at which dark pixels turn to pure black. By changing the black point, you can make dark areas darker, without resorting to adjusting the exposure for the entire photo.

▶ **TIP** When you're adjusting sliders, you don't have to move your finger on the slider itself. You can drag within the image, too, to change the settings.

Adjust color

The Color control operates like the Light control—you can choose to adjust a master slider for easy editing, or expand it to reveal the list of individual controls that cover the following characteristics:

- **Saturation:** This control adjusts the intensity of color in the image (5.52).

- **Contrast:** Color contrast involves increasing the separation between similar colors.

- **Cast:** If a photo has a color cast—in many cases, being too warm or cool—the Cast slider can help compensate.

What you won't find is a dedicated White Balance tool; the Cast slider compensates for that.

5.52 Increasing Saturation

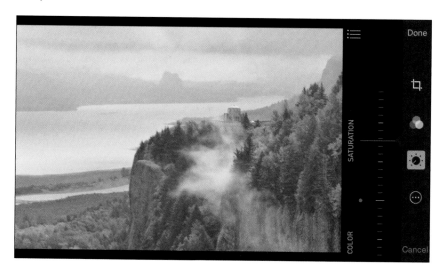

Photos for iOS as the First Line of Editing

After you've used the editing tools in Photos for OS X, you may feel constrained when you tackle some images on an iPhone or iPad. I'd love to be able to eradicate some dust spots with the Retouch tool and adjust the white balance, for example, but those tools don't exist in the iOS version of Photos.

This tag-team editing on iOS and OS X works well with iCloud Photo Library enabled, but it also works if you import photos into Photos for OS X by connecting your device to your Mac via sync cable. The edits are copied along with the image, and you can change their individual values if you'd like.

So, in general, I think of editing a photo on my iPhone as a good first draft. It helps to nail down the tones, colors, and composition. Then, I'll work on the image again later on the Mac, where I have access to more tools (5.53).

Original

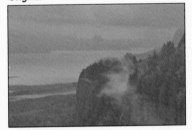

After editing in Photos for iOS

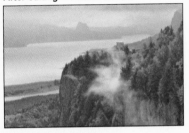

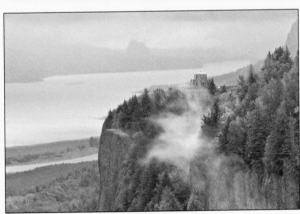

After editing in
Photos for OS X

5.53 Editing in both iOS and OS X

Black and white

If you recall the discussion of the Black & White tool on OS X, you no doubt remember that the individual sliders are used to accentuate the setting of the main slider, instead of merely storing the values. The same is true with the B&W tool on iOS (5.54).

5.54 Fine-tune the B&W effect.

Once you've settled on a black and white treatment you like, use the following controls to enhance it:

- **Intensity:** This adjustment increases or decreases the black and white effect you've chosen. With a dark treatment, increasing Intensity makes it darker; with a light treatment, increasing Intensity makes it lighter.

- **Neutrals:** Drag this slider to darken or lighten the gray midtone areas.

- **Tone:** The Tone adjustment increases or decreases the contrast.

- **Grain:** This slider adds simulated grain that approximates the look of some black and white film stock.

▶ **TIP** In the editing view, you can zoom in by pinching outward with two fingers to get a closer look at an area of the photo. When you tap an edit tool, however, the image is zoomed out to fit the entire photo onto the screen.

Edit using other iOS apps' tools

The iOS version of Photos has a feature that its Mac sibling doesn't (yet) possess. Developers can create extensions of their apps that work within Photos, adding or replacing functionality in Photos without requiring you to switch to the other app.

If you have apps installed that offer extensions, you need to enable them:

1. Tap the Extensions button in the editing view.

2. In the dialog that appears, tap the More button **(5.55)**.

5.55 Set up extensions.

Extensions button

3. Choose which app extensions to include by tapping the activation switches at right (5.56). Tap Done.

5.56 Choosing photo app extensions

Photo Editors		Done
Scanner Pro		
Pixlr		
Pixelmator		

Now that the dialog is populated with more options, you can use one to edit your photo. Here's how:

1. Tap the Extensions button.

2. Tap the icon of the editor you want to use (5.57).

3. Choose a tool from the bottom of the screen (5.58) and use it to adjust your image.

4. Tap Done to exit the extension and return to the Photos editing view.

5.57 Pick an app to use its editing tools.

5.58 Some of Pixelmator's editing tools within the Photos editing view

Edit Videos in Photos for iOS

I shoot more video on my iPhone now than I ever did when I owned a camcorder. Being able to quickly trim clips makes them easy to share (and I can lop off the parts where I forgot to stop recording after the main action occurred).

Trim a clip

Open a video clip in Photos and do the following to trim a clip:

1. Tap the Edit button.
2. Touch and drag one edge of the filmstrip at the top of the screen to enter the Trim mode; the filmstrip gains a yellow border.
3. Drag the edges of the filmstrip to define the portion of the clip you want to keep (5.59).
4. Tap the Trim button.
5. When asked, tap Save as New Clip to continue. Photos automatically saves the original clip.

5.59 Select the portion of the video to trim.

Edit Slo-Mo video

Slo-Mo videos add the ability to choose which section of the clip plays at the slow speed. (Remember, the entire video is shot at 240 fps or 120 fps.) When editing a video, the slow motion controls appear below the filmstrip; drag the handles to specify the duration of the slow section (5.60).

5.60 Slow motion controls

Slow motion section

▶ **NOTE** When you want to do more than just trim clips, look into iMovie for true video editing. Its main benefit is being able to assemble clips on a timeline, edit audio, apply effects, and otherwise build a movie. I cover all of that and more in my book *iPad and iPhone Video*.

Edit video using other apps' tools

Just as you can edit photos using tools from other apps, video clips can be edited, too. In fact, I like the video aspect of editing extensions because I can do something as simple as adding a title from iMovie without starting an entirely new project in the app. Or, for example, I can use the extension provided by the app Emulsio (www.creaceed.com/emulsio) to stabilize shaky footage, right in the Photos app! Here's how:

1. Open a video and tap the Edit button.

2. Tap the Extensions button.

3. Tap the app whose features you want to use (5.61).

4. Edit the clip using the tools from the other app (5.62).

5. Tap Done when you're finished.

Extensions button

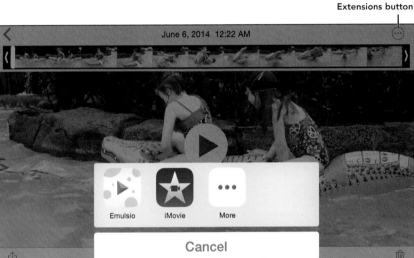

5.61 Choose an app to edit the clip.

5.62 Use the other app's tools to edit the video clip.

Share Photos and Videos

One of the best documentaries I've seen recently is *Finding Vivian Maier*, about a nanny who shot amazing street photography throughout her life—but no one knew just how good she was because she never shared her photos during her lifetime. It wasn't until someone bought her immense stash of negatives that her photos were discovered.

We all have our reasons for capturing photos, but I think it's safe to say that most people want to share the images with family members, friends, or the entire world. This chapter is about taking the pictures you've organized and edited and making them available to other people. That ranges from sending shots to a select group using iCloud Photo Sharing, to posting them on social networking or photo-sharing sites.

iCloud Photo Sharing

My favorite feature of iCloud Photo Sharing—which is not part of iCloud Photo Library, although they work nicely side by side—has nothing to do with what happens on my Mac or iOS device.

The idea behind the service is that you create an album of photos and share it with people you invite. That can be one person or several, but here's the great part: As soon as you add an image or video to the album, it's copied to the devices of each subscriber. Before iCloud Photo Sharing, I'd send photos of my daughter to family members via email (which would sometimes get delayed by spam filters) or I'd post them to a photo-sharing service like Flickr (which anyone can view, and which some folks would forget to check).

Those methods are still viable ways to share photos, as I describe in this chapter, but with iCloud Photo Sharing, my family members receive a notification when new photos are added and the pictures are saved to their Photos libraries. I also set it up so that my wife can also post her own photos, so I also get a copy of the shots she takes.

Create a shared album

To get started, make sure iCloud Photo Sharing is enabled on your Mac in the Photos preferences, under the iCloud tab, or on an iOS device in Settings > iCloud > Photos.

Next create a shared album. In Photos for OS X, do the following:

1. Select one or more photos you wish to share.

2. Click the Share button and choose iCloud Photo Sharing (6.1).

3. In the Add to Shared Album sheet that appears, click New Shared Album.

4. Give the album a name.

5. In the To field, enter the names or email addresses of the people you'd like to invite to view the album.

6. Optionally enter a comment that the people will see when they're invited, and click the Create button.

The invitees will receive a notification (if you've provided an iCloud address) and an email asking if they would like to join the album. You're notified when they do.

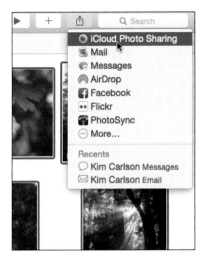 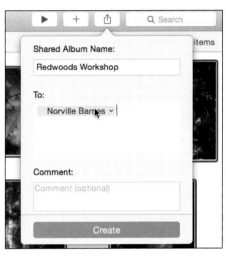

6.1 Share via iCloud Photo Sharing and then create a new shared album.

On an iPhone or iPad, create a new album using these steps:

1. Select one or more photos and tap the Share button.

2. Tap the iCloud Photo Sharing option.

3. In the dialog that appears, tap Shared Album.

4. Tap New Shared Album.

5. Give the album a name and then tap Next.

6. Enter the names or email addresses of the people you want to invite, and then tap Next.

7. Optionally type a comment and then tap Post to create and share the album.

Add photos and video to a shared album

The next time you capture or edit a photo you want to share with everyone subscribed to that album, there are two ways to do it: select photos first, or navigate to the shared album and add items from there.

To select items first:

1. Select the photo(s) you want to share.

2. Click or tap the Share button and choose iCloud Photo Sharing.

3. In Photos for OS X, add an optional comment and then select the shared album.

 In Photos for iOS, add an optional comment and make sure the album you want is listed in the Shared Album field; if it's not, tap it and select the right album. Tap Post.

To add items from within the shared album:

1. Tap the Shared button and navigate to your shared album (you may have to tap or click the Back button to exit the Activity screen).

2. In Photos for OS X, click the "Add photos and videos" button.

 In Photos for iOS, tap the Add (+) button.

3. On each platform, you're taken to the Moments view; click or tap the items you want to add, and then choose Add (Mac) or Done (iOS) to include them in the album.

The photos are added to the album on your Mac or device, and everyone else receives a notification that new photos are available. When they access the shared album, it opens to the Activity screen in the Shared albums section, where the photos appear (6.2).

▶ **NOTE** If you've enabled Family Sharing, a shared photo album is automatically created for the family to use. It's just one album, but any family member can view it and contribute to it.

Invite people to a shared album

If you want to add other people to the shared album, extend an invitation:

1. On the Mac and iOS versions of Photos, click or tap the Shared tab and open the shared album you want; you may need to click or tap the Back button first to exit the Activity screen.

2. On the Mac, click the People button and enter a name or email address in the To field (6.3).

 In Photos for iOS, tap the People button, tap Invite People, and enter the person's information.

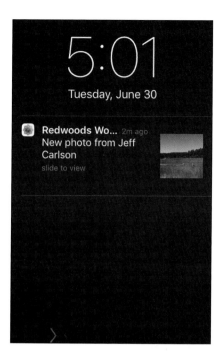

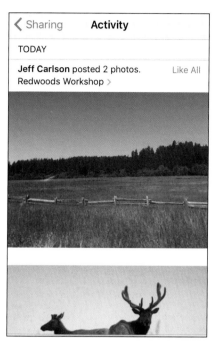

6.2 A notification arrives that new photos are available, found in the Activity screen of the Shared albums view.

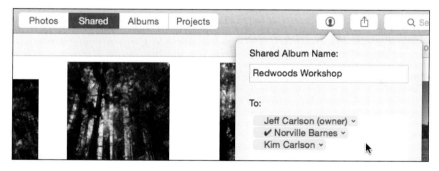

6.3 Add people to the shared album. The checkmark indicates someone already subscribed.

This is also where you can remove people from the list of recipients or re-send invitations for those who didn't receive them. You'll also find the Subscribers Can Post option, which lets anyone contribute to the album, as well as an option to publish the album as a public Web site, a control to turn off notifications about the album, and the ability to delete the shared album entirely (for subscribers, the option is to unsubscribe).

▶ **TIP** Subscribers can't delete items from the album, even if the option to let others post is enabled.

Share via Messages or Mail

It wasn't too long ago that sharing photos to someone via text messaging was an insane idea, because the phone carriers charged so much per message. Now, with iMessage, that worry is gone, and I find myself sending photos often.

At the same time, I almost never send photos via email because there are too many impediments between me and my recipients: mail servers get clogged, spam filters block images, and often large attachments are stripped away. Still, sometimes it's the only way to pass along an image to someone, and the Photos apps on OS X and iOS can handle it.

To share one or more photos via Messages or Mail, do the following:

1. In Photos for OS X or iOS, select the photos and click or tap the Share button.

2. Choose Messages or Mail from the pop-up menu or share sheet. A new outgoing message containing the images appears; on the Mac, the message opens in the Mail application.

3. Enter the name or address of your recipient and click Send.

In the Mail application on the Mac, you can also choose the size of the image that gets sent. Click the Image Size pop-up menu and pick one before sending (6.4).

6.4 Choose an image size to send via email.

Share via AirDrop

Want to share a photo or video to someone who's physically near you? Apple's AirDrop technology makes it easy. Make sure the devices—iOS or Mac—are nearby, and then:

1. In Photos for OS X or iOS, select one or more photos to share.

2. Click or tap the Share button.

3. On the Mac, choose AirDrop and wait for your friend's device or Mac to appear. The other person must have the iOS device on, or have AirDrop selected in a Finder window.

 On an iOS device, the other person's device will show up in the AirDrop area of the share sheet (6.5).

4. Click or tap the destination device's icon; the other person must agree to receive the image(s) before the transfer begins.

6.5 A friend's device appears to share via AirDrop.

▶ **TIP** If the other person isn't showing up in the AirDrop pane, try setting their AirDrop preference to Everyone. On iOS, swipe up to reveal Control Center and tap the AirDrop button; on the Mac, check your firewall settings in the Security & Privacy preference pane.

▶ **NOTE** To share via AirDrop between iOS devices and Macs, you need a Mac newer than 2012. Some earlier Macs can share via AirDrop with other Macs.

Share to Online Services

To share your photos and videos with the world, the most direct method is via social media services like Facebook, Twitter, and Flickr (among many others). Photos makes it easy to do so directly from within the app—no copying and pasting, exporting, uploading, and all that.

Instead, do the following:

1. Select one or more items in Photos for OS X or Photos for iOS.

2. Click or tap the Share button.

3. Choose a supported service, such as Facebook, from the list that appears.

4. Type a message to accompany the images (6.6).

5. Set any service-specific options, such as an optional location, audience, or album name.

6. Click or tap Post to publish the images.

6.6 Sharing to Facebook

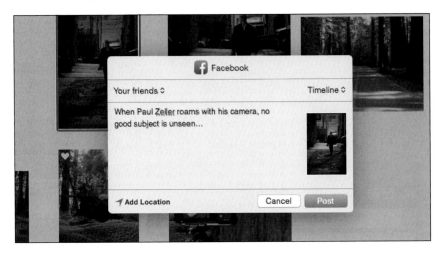

> ▶ **NOTE** Make sure you're signed in to the supported services you wish to use: on a Mac, open System Preferences and log in using the Internet Accounts preference pane; on an iPhone or iPad, go to Settings and find the services in the list.

Share to Other Services

The Photos application on both platforms supports sharing extensions, which allow developers to support sharing directly to their apps. For example, you could send an image to your Pinterest, Evernote, or Slack account.

To configure services using sharing extensions, do the following:

1. Select a photo and click or tap the Share button.

2. Choose More from the options listed.

3. On iOS, enable the services you want to include in the Activities window (6.7), and then tap Done.

 On OS X, choosing More opens the System Preferences with the Extensions pane selected. Select services to include in the Share Menu list.

Those items now appear in the Share menus.

iOS

OS X

6.7 Enabling share extensions

▶ **NOTE** The Share menu also includes a helpful shortcut: Set Desktop Picture (Mac) or Use as Wallpaper (iOS). Turn your beautiful photos into backgrounds with no hassle.

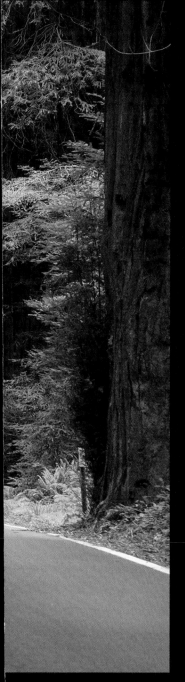

CHAPTER 7

Make Projects

Too often with our photos, this is the end of the story. We capture, import, edit, and share a few, and then move on to the next photo adventure and start the process again.

You'll notice a distinct absence of paper. For most of the history of photography, a "photo" didn't exist beyond the negative until it was printed on paper.

Digital photography has pushed paper away, but now there are actually many more options for putting images to paper—you don't need to leave Photos for OS X to do them. Using the application's Projects features, you can create photo books, calendars, cards, and prints, order them from Apple, and have them printed and delivered.

And while you're waiting for the goods to arrive, you can take those photos and build a slideshow you can show friends on the Mac, an iOS device, or an Apple TV.

Slideshow

The Photos application actually has two slideshow options: You can play an impromptu slideshow within the program (on OS X and iOS), or you can build a slideshow as a project where you have control over titles, transitions, and music.

Play a slideshow in the app

In Photos for OS X, any moment, collection, or album can be played as a slideshow:

1. Click the Slideshow button at the upper-right corner of the moment or collection (7.1), or the Slideshow button that shows up in the toolbar when you're viewing an album.

2. Choose a theme from the list provided.

3. Each theme has its own song; if you'd rather choose something from your music library, click the Music button and select something else. To remove the music, deselect the current song.

4. Click the Play Slideshow button to start the show, which plays full-screen. Press the Esc button to exit and return to Photos.

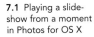

7.1 Playing a slide-show from a moment in Photos for OS X

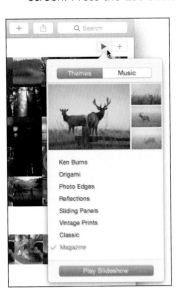

In Photos for iOS, you take a slightly different approach:

1. In a moment or album, open the photo that will be the starting image.

2. Tap the Share button.

3. Tap the Slideshow button (7.2). (Although you can select more than one photo on this screen, you don't need to; the first selected image marks the first slide.)

4. In the Slideshow Options screen, choose an output device (such as an Apple TV if one is on the network; otherwise, stick with your current device), choose a transition, and decide whether to play a song.

5. Tap Start Slideshow to begin the show. Tap anywhere on the screen during the presentation to end it.

▶ **NOTE** If your library contains optimized versions of photos, you may have to wait a few seconds or minutes for the full-resolution versions of those images to download before the slideshow begins.

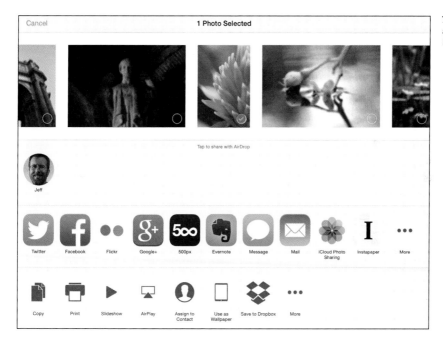

7.2 Setting up a slideshow in Photos for iOS

Create a Slideshow project

When you want more creative control over the slideshow, create a Slide-show project on the Mac:

1. Select the photos you want to include. That can be in the Photos view or in an album, or you can navigate to a collection or moment if you want to share all the photos from that time period.

2. Click the Add (+) button in the toolbar, or the same button belonging to a moment or collection at the right side of the window, and choose Slideshow.

3. In the dialog that appears, choose New Slideshow and give it a name. Click OK.

The slideshow is built using the photos in the order they appear in the view or album. To edit the slideshow, do any of the following:

- **Re-order slides:** Select one or more slides and drag them to a new position in the timeline at the bottom of the window (7.3).

7.3 Reordering slides

- **Delete slides:** Photos makes it easy to create a slideshow, but it's up to you to make an interesting one. Your viewers will appreciate you removing repetitive shots (such as those captured in bursts in the same location) and those photos that are just middling quality. Select one or more photos and press the Delete key, or choose Image > Delete Slides; they're removed just from the slideshow, not your photo library.

- **Add titles:** The first photo automatically includes the title of the album or the moment. Select the title proxy (the black box with a T) and then edit the text in the preview area (7.4).

 To add a title, click the Add (+) button to the right of the timeline and choose Add Title.

7.4 Editing a title

► **TIP** Each theme uses its own font and size for text, but you can change it. Choose Edit > Fonts > Show Fonts (or press Command-T) and make any adjustments you want.

• **Add photos:** Click the Add (+) button to the right of the timeline and choose Add Photos (7.5). Next, select the images you want to add; shots already in the slideshow appear with a gray checkmark. Click the Add button to put the new selections into the slideshow.

7.5 Add more photos to the slideshow.

• **Change the theme:** Click the Theme Picker button at the right to apply a different theme to the slideshow.

• **Make the slideshow loop or not:** Click the Loop button below the preview to set the slideshow to restart when it reaches the end (the default) or play once and stop.

- **Change the song:** If you want to hear something other than the theme's default song, click the Music button (7.6). Choose any of the other theme songs, or choose iTunes from the Music Library pop-up menu and select something from your own set of tunes. If you want silence, click the X that appears when you hover over the Selected Music item.

- **Choose a transition:** Click the Duration Options button and choose an effect from the Transition pop-up menu (7.7); the setting applies to the entire slideshow, not individual slides. The Speed and Direction controls dictate how fast and from which side the transition occurs.

- **Change the duration of the slideshow:** The Duration buttons let you set a custom overall time (which is calculated for you when you first create the slideshow). Or, choose Fit to Music to play all the slides in the time it takes for the music to play.

- **Change the timing of selected slides:** The duration options apply the same amount of time to every slide, but you can override that in some cases. Select one or more slides and then click the Play Selected For checkbox to make those appear onscreen shorter or longer.

- **Scale photos:** When the "Scale photos to fit screen" option is enabled, the application makes each entire image visible, adding black bars to the sides or top as needed.

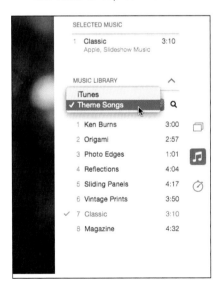

7.6 Music options

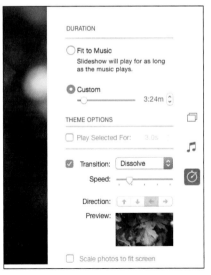

7.7 Duration options

- **Export the slideshow:** Click the Export button to create a movie file of the finished slideshow if you want to take it outside the Photos application. You can optionally choose to have it added to your iTunes library (to sync it to a device later).

 Since I rarely sync items through iTunes anymore, I prefer to put the movie file into a Dropbox folder, where I can download it from my iOS devices. When iOS 9 is released in the Fall of 2015, there will also be the ability to open files stored in your iCloud Drive folder.

Click the Preview button at any time to play the slideshow within the window. When you're done setting it up, click the Play button to play the slideshow full-screen.

The slideshow is saved in the Projects view for the next time you want to view or edit it.

▶ **TIP** There's no way within the Slideshow project to edit the photos—say, if you want to crop or adjust them—but you can return to the images in the Moments or Albums views and edit them there. The changes apply to the image in the slideshow.

Photo Book

I discovered an old set of photo prints in a drawer the other day that had been forgotten for years. It was a fun find, but it reinforced how invisible photos become when they're put away—out of sight, out of mind, as the old saying goes. A photo book, however, gets more attention. Even when it's put away in the bookcase, its spine is there to announce itself. Plus, it's easier to flip through a photo book than to paw through prints.

In Photos for OS X, you can build a book, order it through the application, and have a professionally printed product in your hands within a few days. Or, order a book as a gift and put it into someone else's hands.

To create a Book project, start by doing the following:

1. Select the photos you want to include. That can be in the Photos view or in an album, or you can navigate to a collection or moment if you want to share all the photos from that time period.

> ▶ **TIP** Making projects is when I like having smart albums set up. For example, I can quickly find all favorited photos captured during a time frame, such as a vacation. See Chapter 3 to learn how to make smart albums.

2. Click the Add (+) button in the toolbar, or the same button belonging to a moment or collection at the right side of the window, and choose Book.

3. In the dialog that appears, click the Select button for the size and style of book you want to create: Square, Classic, or Softcover. Although the prices are listed, you're not committing yourself to any purchase yet. You can change the book type later, but keep in mind that if you're shifting sizes, that could affect layout and text you add.

4. Choose a layout theme on the next screen and then click Create Book. You'll probably want to test several themes at first; you can change the theme easily after this step.

The photos you selected are automatically added to the book's pages.

> ▶ **TIP** It's also possible to create an empty book and then add photos to it after it's made. Go through the previous steps, but make sure no photos are selected, and use the Add (+) button found in the toolbar to choose the Book option.

Add or remove pages

Note that the pricing is based on a 20-page book, with additional fees per page as you add more pages. The current number of pages and the price appear at the upper-right corner of the window.

To delete a few pages, select the ones you want to delete and choose Remove Pages from the Add or Remove Pages button (7.8). Or, click the Project Options button and drag the Number of Pages slider to the amount you want. If you're looking at a much bigger book than you expected, feel free to scratch pages with abandon—the photos are placed in the Photos bin at the bottom of the window for you to grab later. The same pop-up menu also lets you add pages if necessary.

To rearrange pages, select one or more and drag them to a new position within the book.

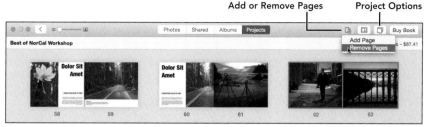

Add or Remove Pages Project Options

7.8 Removing pages from the auto-created book

Change a page's layout

The Photos application randomly assigns layouts to the pages, depending on the theme. Each page can include from 1 to 12 photos, plus titles and text options. To change a page's layout, do the following:

1. Double-click a page to zoom in and edit just that two-page spread.

2. Click the Options button to view the Layout Options window.

3. Select one of the pages and then choose a layout style in the Layout Options window (7.9).

▶ **TIP** Make sure you scroll down to view all the options, such as two-page spreads and maps based on the geolocation data in the associated photos.

▶ **TIP** You can also change pages' layouts in the book's overview. Choose Window > View (Command-I) to view the Layout Options window, select the page you want to change, and click a new layout.

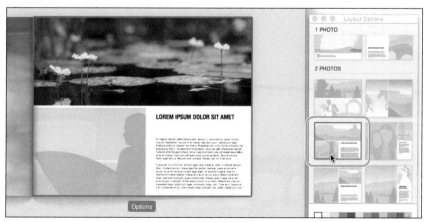

7.9 Choosing a new page layout

Add or remove photos

To fill a blank spot or replace an existing photo, drag an image from the Photos bin onto that section of the page's layout. Or, drag a picture out of the page and into the Photos bin to remove it.

If you remember a photo that would be perfect in a spot but wasn't included initially, click the Add Photos button above the Photos bin to search your library for the image.

Edit photos and text

With a layout established, you can fine-tune the appearance of each page. Double-click a photo to edit it and do any of the following:

- To adjust how the photo fits into its frame, drag it into position. You may need to change the Zoom & Crop slider in the Photo Options window (7.10).

- To apply a filter to the image, click one of the filters in the Photo Options window. Or, click the Edit Photo button to switch to the editing view and use all of the application's editing tools (see Chapter 5).

- Click within a text element to rewrite the text.

Lastly, when your book is ready and you've proofed the text (a fifth or sixth or tenth time), click Buy Book to place an order.

7.10 Edit individual photos on a page.

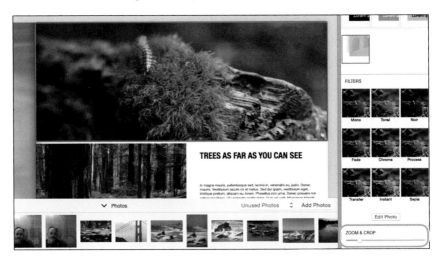

Calendar

To make sure your photos are seen all year, why not create a calendar that features them? (This option is a big hit with grandparents.) Here's how to create one:

1. Select the photos you want to include, and choose Calendar from the Add (+) button. Or, click the button with nothing selected to start with an empty template.

2. Choose how many months will be in the calendar (from 12 to 24), and the month it begins. Click Continue.

3. Choose a theme and click Create Calendar.

Once that's set up, there are a number of ways to customize it:

- Select a page and click the Layout Options button to change how many photos appear on each page.

- Rearrange the pages by dragging them into position. (The months remain in chronological order, of course.)

- Double-click a photo to edit it: zoom, crop, apply filters, or open the editing view, just as with Book projects.

- Click the Calendar Options button to include national holidays and birthdays from your Mac's Calendar and Contacts applications (7.11).

- Click within any date to add your own notes or events.

When the calendar looks good, click the Buy Calendar button to order it.

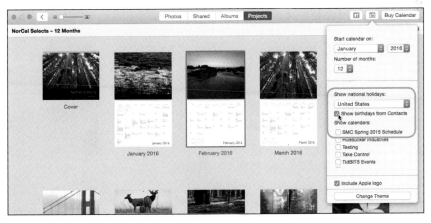

7.11 Add holidays and birthdays automatically.

Prints

My daughter's teacher had an odd request: Bring in a photo of our family. I didn't have one. Oh yes, I have plenty of pictures of us stored in my photo library, but nothing I could put in her backpack. It turns out that photo prints aren't so passé after all.

1. Select the photos you'd like to create prints from, and choose Prints from the Add (+) pop-up menu.

2. Choose a size and style, ranging from automatically sized prints based on the photos' dimensions to standard prints and posters.

▶ **TIP** The Auto-Sized option is fun if you shoot panoramas—they're printed wide and intact, not cropped.

As with the other projects, you can do a few things to make sure the photos appear their best before placing an order:

• The print size is set at the outset, so you don't need to worry about pre-cropping photos to the correct aspect ratio in the editing view. In the Prints interface, double-click a photo and drag it to place it in its frame; the Zoom & Crop slider in the Photo Options window helps with composition.

• Click the button next to the Photo Options button to change or add photos, change the print size, or add a new print size to the order. For example, you could select one of your photos and order a poster of it in addition to the bevy of 4x6 prints (7.12).

7.12 Order multiple print sizes in the same order.

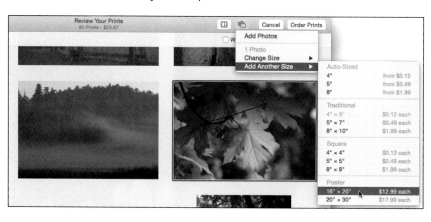

- If you want multiple copies of an image, select it and enter the number in the Prints portion of the Photo Options window.

- Choose whether to print with white borders or a glossy finish (or both) by marking the options at the top of the screen.

Click the Order Prints button to place the order. If you're not ready yet, click Cancel; you'll have the opportunity to save the order for later.

Cards

At some point in the last few years, nearly all of the holiday cards I started to receive were photo cards. (No real surprise, since those are the type I was sending, too!) Photos can create cards for all sorts of occasions:

1. Choose one or more photos to use for the card, and choose Card from the Add (+) pop-up menu.

2. Choose the type of card you want: Letterpress, Folded, or Flat.

3. Select the card's theme, and whether it should be landscape or portrait orientation. The Featured themes appear initially, but you can choose other types and occasions from the pop-up menu at the top of the window (7.13). Click Create Card.

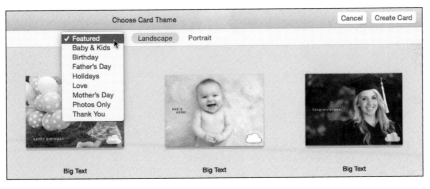

7.13 Choose the card's theme.

4. If you selected multiple photos or chose a card theme that supports more than one image, drag the shots from the Photos bin to the card front.

5. Click the Layout Options button if you want to choose an alternate layout for the card face.

6. Click the text on the card to change it and type something custom.

7. Double-click the photo to edit its composition or appearance (7.14).

8. Click the Inside and Back buttons and select from the available layouts and photo options (such as adding an inside greeting or including a small photo on the back).

9. Click the Buy Card button when you're ready to check out.

7.14 Edit the card's photo.

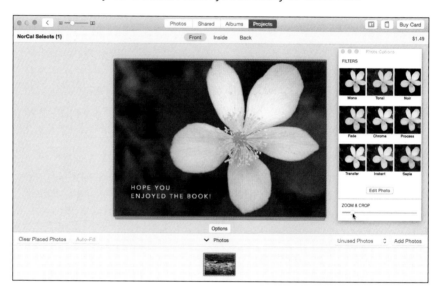

INDEX

Numbers

10 images per second,
 capturing, 12
645 Pro Mk III app, 22

A

AirDrop, using to share photos,
 159
album icons, rearranging, 68
albums. *See also* events as
 albums; shared albums; smart
 albums
 adding photos to, 67–69
 choosing cover photos, 68–69
 creating, 64–66, 69–71
 and folders, 66
 removing photos from, 69
 reorganizing photos in, 68
 viewing photos by, 48–49
Aperture
 custom fields, 33
 replacement of, 25
 using to merge libraries, 30
Apple Watch
 capturing photos, 8
 reviewing photos, 8
apps. *See also* Camera app
 645 Pro Mk III, 22
 Camera+, 21
 Hydra, 23

Manual, 21–22
 ShutterSnitch, 55
aspect ratio, cropping
 images to, 110

B

backgrounds
 considering in composition, 9
 turning photos into, 161
backing up photo libraries, 26–27
Black & White controls
 Grain, 123, 146
 Intensity, 123, 146
 Neutrals, 123, 146
 in OS X, 122–123
 Photos for iOS, 146
 Tone, 123, 146
black points
 adjusting in iOS, 144
 adjusting in OS X, 117
Book project
 adding pages to, 170–172
 creating, 169–170
 creating projects, 169–170
 Layout Options window, 171
 rearranging pages, 170
 removing pages from, 170–172
 using smart albums with, 170
Brightness control, in iOS, 143
burst mode, using in Camera
 app, 12–13
Bursts smart album,
 opening, 71–72

trimming clips, 134–135

volume controls, 133

videos. *See also* editing videos

 adding to shared albums, 155–156

 duplicating, 134

 shooting with

 Camera app, 17–18

 Slo-Mo mode, 18–19

 Time-Lapse mode, 20

viewing

 by albums, 48–49

 locations, 45–48

views

 Collections, 40–42

 displaying, 40

 Moments, 40–41

 navigating, 40–43

 scrolling to tops of, 42

 switching between, 40–41

 Years, 40–42

Vignette control

 Radius slider, 126

 Softness slider, 126

 Strength slider, 126

 using in OS X, 125–126

volume controls, adjusting for video, 133

W

Web sites. *See also* apps; Camera app

 645 Pro Mk III app, 22

 Camera+ app, 21

 Emulsio app, 150–151

 Hydra app, 23

 Manual app, 21–22

 Photos and iPhoto, 36

 ShutterSnitch app, 55

White Balance controls

 Neutral Gray, 120

 in OS X, 119–120

 Skin Tone, 120

 Temperature/Tint, 120

white points, adjusting in OS X, 117

Y

Years view, 40–42

Z

zoom feature

 accessing in Camera app, 13

 keyboard shortcut, 123

Powerful Ideas. Inspired eBooks.

Need a little boost? Then fill up on Fuel! Packed with practical tools and tips that will help you quickly advance your creative skills, these short eBooks get right to the heart of what you need to learn. Every FuelBook comes in three formats—MOBI, ePUB, and an elegantly laid out PDF—so you can choose the reading experience that works best for you on whatever device you choose. Written by top authors and trainers, FuelBooks offer friendly, straightforward instruction and innovative ideas to power your creativity.

For a free sample and more information, visit: fuelbooks.com